TOM THOMSON
THE LAST SPRING

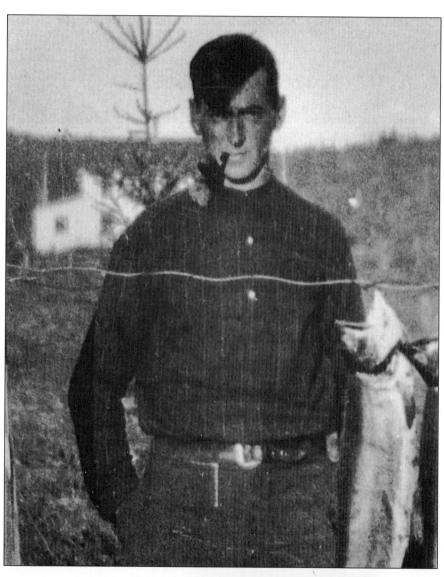

TOM THOMSON
THE LAST SPRING

JOAN MURRAY

Dundurn Press
Toronto • Oxford

Editor: Doris Cowan
Separations by Goody Color Separation (Canada) Ltd.
Printed and Bound in Canada by Metrolitho Inc., Quebec

The publisher wishes to acknowledge the generous assistance and ongoing support of the **Canada Council**, the **Book Publishing Industry Development Program** of the **Department of Canadian Heritage**, the **Ontario Arts Council**, the **Ontario Publishing Centre** of the **Ministry of Culture, Tourism and Recreation**, and the **Ontario Heritage Foundation**.
 Care has been taken to trace the ownership of copyright material used in the text (including the illustrations). The author and publisher welcome any information enabling them to rectify any reference or credit in subsequent editions.

J. Kirk Howard, Publisher

Canadian Cataloguing in Publication Data

Murray, Joan
 Tom Thomson : the last spring

Includes bibliographical references and index.
ISBN 1-55002-218-0

1. Thomson, Tom, 1877–1917. I. Title.

ND249.T5M8 1994 759.11 C94-932133-8

759.11
T485
M982
ev.2

Dundurn Press Limited
2181 Queen Street East
Suite 301
Toronto, Canada
M4E 1E5

Dundurn Distribution
73 Lime Walk
Headington, Oxford
England
0X3 7AD

Dundurn Press Limited
1823 Maryland Avenue
P.O. Box 1000
Niagara Falls, N.Y.
U.S.A. 14302-1000

CONTENTS

LIST OF FIGURES

Tom Thomson: Sources of His Brilliance

Tom Thomson has fascinated me for more than two decades. Twenty years ago I organized the first retrospective look at his work, *The Art of Tom Thomson*, at the Art Gallery of Ontario. Since then I have been working on a *catalogue raisonné*, a detailed chronicle and inventory of his several hundred works. This is essentially a technical job of listing and recording, but there is one great pleasure involved: as the French term implies, the cataloguer has an excellent opportunity to *reason* the artist's work into a coherent *oeuvre*. Cataloguing Thomson's art, I have often thought about the sources of his brilliance. Eight years ago I wrote a little book, *The Best of Tom Thomson*, and again found myself musing about his work, particularly his oil sketches: I saw in them what seemed to be the embryonic forms of many masterworks – masterworks sadly left unpainted because he died so young.

In 1991 I took a new look at Thomson in the context of work by contemporary artists, and produced an exhibition for the Robert McLaughlin Gallery in Oshawa, which I direct, titled *Echoes of Tom Thomson*. It circulated to the Tom Thomson Memorial Art Gallery in Owen Sound, near where Thomson grew up. It occurred to me that one of Thomson's great contributions to Canadian art was the creation of works that served as catalysts for generations following him. In 1991 I prepared a monograph, "The World of Tom Thomson," for the W.L. Morton Lecture at Trent University in Peterborough (published by the *Journal of Canadian Studies*), viewing Thomson's work as a chronicle of his physical environment. The present publication offers a look at a mysterious series of sketches Thomson painted in the last spring of his life.

Like other critics, I have been influenced in my view of Thomson by more recent work. In 1971 it seemed natural to emphasize Thomson's radical innovations in colour. Abstract painting was in its heyday, and I was among those who enlisted Thomson, through his "abstract" sketches, as a kind of pioneer of the movement. I never denied the representational element of his art but in both my work and in the later writing of Harold Town, the relationship of his work to nature tended to be discounted. "He was poised for the jump [from realism to abstraction] when he died," wrote Town.[1] What mattered then, for us, was tracing Canadian abstraction's lineage back to its source in Thomson's experiments. As the first abstract painter, he was the forerunner of some very exciting artists.

Further research has led me to take a wider view of Thomson's essential qualities. It now seems clear to me that he was just as deeply involved with the creation of the historical and environmental record. Examining the subjects with an eye to the reality they evidently had for him makes them live for us again. In this book the works of 1917 that I have identified are laid out in rough chronological order, to provide a kind of narrative. They are all sketches in oil. Like his other sketches, they are usually 21.6 x 26.7 cm, although in 1917 he also did a number of 11.8 x 17.2 cm sketches.

Thomson told his friend Mark Robinson that he had painted sixty-two works in Algonquin Park that spring (I have included Robinson's accounts in Appendix I). He may have exaggerated slightly, but whatever the number was, he pruned the group before he died. In a letter to his friend Dr. MacCallum, of 21 April 1917, reproduced in

Appendix I, he said he had "scraped quite a few." That is, he scraped off the paint and repainted, as in Plate 26. He must have destroyed others. When he died, Robinson went through his gear to see what was there. He found about forty pictures, certainly less than the number of which Thomson had spoken.[2] I have found thirty-eight.

I am grateful to John Wadland for his patience with my Morton Lecture, and for his helpful suggestions. William H. Graham helped my research immeasurably through his immersion in the Thomson material in the 1970s. I owe him many insights into Thomson, especially about Thomson's life in Seattle. Louise Herzberg answered my questions about Dr. Brodie; Ken Thomson helped with photographs of the works he owns; Eric

Klinkhoff helped with photographs of Thomson sketches in Montreal; Dick Doyle with comments. Some of the photographs for this book were purchased from a research grant given to the Robert McLaughlin Gallery in 1994 by the federal government's Museum Assistance Program of the Department of Canadian Heritage towards an exhibition of the material in this book; I thank the agency for its timely aid, and the gallery board of trustees and staff for their quiet and self-possessed waiting for the show, which we will hold in 1995.

Joan Murray
Oshawa, Ontario

"… have every intention of making some more …"

7 July 1917

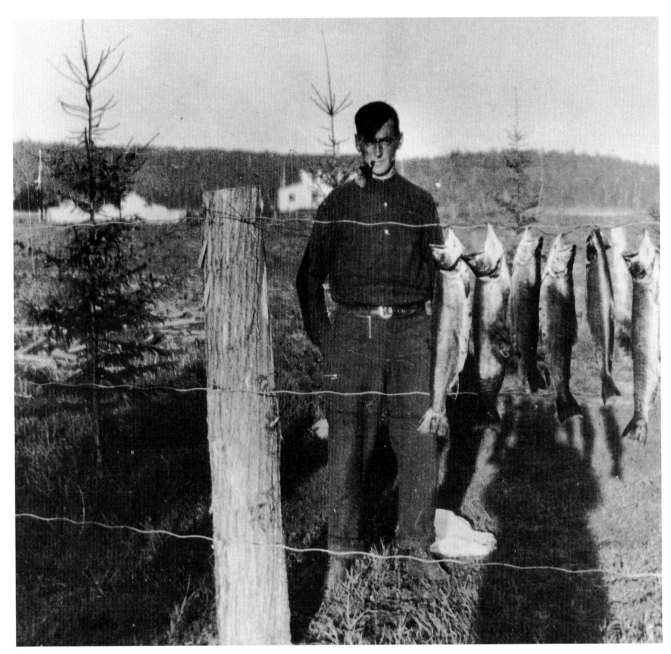

Figure 1

Photograph of Tom Thomson with his catch at Canoe Lake, Algonquin Park, c. 1915

Photograph taken by Lawren Harris (1885–1970). Courtesy of the National Archives of Canada, Ottawa. Gift of G. Blair Laing, Toronto

(NA 125406)

Algonquin Spring: Tom Thomson's Diary

One day in the summer of 1917, Tom Thomson dashed into the cabin of Mark Robinson, a park warden, in Algonquin Park. Thomson was no stranger. He had been at home in the park for five years, and although he visited only from spring till the fall, he was regarded as a local. Robinson had grown accustomed to Thomson's tall, lithe figure and craggy, friendly face. He knew Thomson's moods: he had seen him smiling and happy, depressed and defeated, sometimes angry. On this occasion Thomson came at a run, like a wild man.

He bounded into the cabin with a question. He wanted to know if he could hang his "records," as he called them, in Robinson's cabin. These were works he had painted that spring and summer, a canvas a day for sixty-two days, showing the stages of the advancing season. He wanted to leave them on Robinson's walls for the summer.[1] The warden told him he could.

Thomson wanted to see his canvases together. Hanging them, he knew, would show him whether his series worked. Seeing them in one place might even help him direct his thought towards what he might paint in the future. Until now he had worked in the traditional way, making sketches in nature, then developing the canvases in the studio back in Toronto. A series was a new idea for him – and an important one. His use of the word "records" was also important to him. He meant the word in its dictionary sense: he felt that he had created documents of the scene before him, and that by looking at his oil sketches someone in the future would be able to see how Algonquin Park looked through the passage of a season. He saw his work as evidence, a faithful transcription not only of nature but of his daily experience within that

nature. He was, in addition, using "records" in the Impressionist sense, as notations of perception, light, and climatic change, as Claude Monet did in his series.

There may have been another idea in Thomson's mind when he called his work "records," and it lies in his family history. A relation of Thomson's – his uncle, the most prominent person of his clan, since Thomson was of Scottish descent – was the naturalist William Brodie (Fig. 2). His name is seldom mentioned today, but it

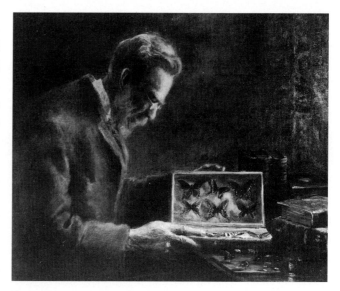

Figure 2
Owen Staples (1866–1949)
The Brodie Memorial Portrait, 1914
Oil on canvas
76.2 x 91.4 cm
Ornithology department, Royal Ontario Museum, Toronto
(Brodie was painted posthumously in this memorial portrait paid for by a subscription from his students, fellow scientists, and friends.)

should be known to everyone interested in the environment. He was one of the finest naturalists Canada ever produced, known not only for his work as an entomologist, ornithologist, and botanist, but also for his intense interest in vertebrate groups and molluscs. He discovered some twenty new species of insects and many new forms of previously described species. From 1903 until his death in 1909 he was director of the Biological Department of the Provincial Museum in Toronto.

He was also a thoroughly fascinating and engaging human being, whose generous and affectionate encouragement of young people was well known. Perhaps the source of his kindness to the young was the fact that his own son had died at an early age – or perhaps it was simply his nature. The Brodie Club at the Royal Ontario Museum, which grew out of the Sunday afternoon gatherings at his Toronto home on Parliament Street, is still in existence today.

Notes made at a meeting of the club more than fifteen years after Brodie died offer some sense of his qualities.[2] One small incident particularly encapsulates his gentle personality: a colleague, visiting his office to talk with him, heard a rustling sound coming from his wastepaper basket. "That's a mouse with nowhere to go," said Brodie. "I feed it there."

At his home he entertained artists, scientists, politicians, and university students. "He especially delighted to have young men about him."[3] He inspired young people, and aroused or stimulated their interest, particularly in natural history.[4] Among others, he encouraged Ernest Thompson Seton, the painter and naturalist, and Charles Trick Currelly, who would become the director of the Royal Ontario Museum. Currelly recalled him as a person who devoted much of his time to boys.[5]

The ways he inspired young people, and the breadth of his interests, were also recalled by colleagues later. "Brodie had not only the eye of the scientist and of the artist but his philosophical mind sought an explanation of what he saw," the Minutes of the meeting in his memory read.[6] Yet he was formally uneducated. His official schooling had lasted only two weeks, he said: the rest of his education came from his mother and his reading. He

had also studied with a doctor for several months, and had learned enough to enable him to set up practice as a dentist in Toronto in about 1857 or 1858 (hence the title "Doctor").

Brodie was famous for his hikes. They started from his house at seven in the morning and kept going for hours. He was remarkable for his acute observation. Among his many interests was philosophy: he liked to debate on Truth, Beauty, and the eternal verities. In this he was not unlike other naturalists of the nineteenth century who saw in nature proof of divine activity, though by this they might not mean "God." The historian Carl Berger has written perceptively of the way this belief equated science with an act of worship and coloured recognition of its laws and facts. "The facts of natural history were not arid, isolated and neutral; they were invested with a mystery and reverence," he wrote in 1987.[7] The description applies to Brodie but does not fully convey his close observation of detail in nature. "His eye saw everything and everything interested him."[8]

That Brodie was loved by his colleagues is clear from the Minutes, and his encouragement was important to them in various lines of research. Also noted was his remarkable accuracy in the identification of species he had never seen. Unfortunately, he was a procrastinator about publishing, perhaps because of his lack of education, or because he never felt he had collected all the information he needed. Yet he kept voluminous notes and journal records of his observations, and encouraged others to do the same. For instance, in 1881, he cautioned Seton against failing to keep a journal of his western travels. "You will be sorry if you omit this," he said, and "you will value it more each year."[9] (Seton's "Journals of his Travels and Doings" covered the next sixty years of his life.) No doubt Brodie gave Thomson similar advice – to keep a full and accurate journal.

Thomson also learned from Brodie the art of finding and preserving specimens; he accompanied his uncle on collecting trips as a young man. He also collected specimens for a high school teacher, David White, in Toronto's High Park and the Scarborough Bluffs – two of Brodie's favourite collecting spots – and he was already taking his

camera along to record scenes that interested him – as witness an early photograph of Scarborough Bluffs taken by Thomson (Fig. 3).

There are similarities between Brodie's life and what we know of Thomson's: both spent a long time choosing a career (Brodie was first a schoolteacher, then a dentist, then a biologist), and both lacked formal education. Most important, both possessed the naturalist's way of seeing, combining keen and enthusiastic observation with a sense of the sacredness of the life of creatures.[10] Maud Varley, the wife of Fred Varley, recalled how on a visit to Algonquin Park Thomson took her by canoe to see the beaver dams.[11] "He was quite shy and very gentle," she wrote. "He got great satisfaction from a baby deer, probably motherless, that came each night and lay down just outside his tent, just to be near somebody."[12]

Having the eye of a naturalist was central to Thomson's work. He saw the land accurately, almost as though it were a contour map laid out before him, and

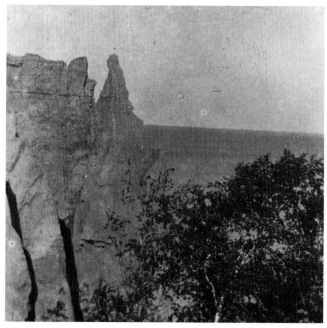

Figure 3
Scarborough Bluffs
Photograph taken by Tom Thomson. Courtesy of Tom Thomson Memorial Art Gallery, Owen Sound, Ontario
Private collection, Toronto

more than that, he had a feeling for the land that no forger could duplicate. He lived and travelled in Algonquin Park until he knew what was behind and beyond everything he painted. He conveyed this knowledge in the small sketches he liked to call his "boards," because they were painted on pieces of wood.

Looking at two Thomson forgeries, we see an ill-defined landscape, half hidden by the smeary paint handling and heavy impasto (Figs. 4–5). They were probably painted by the same hand, perhaps (since the colours are similar) over a short period of time. The way the trees are painted bears no relation to nature; nor is there a feeling that the land extends beyond the scene. Thomson's "inner landscape" – his personal way of seeing, which recognized an overall design in nature, evidence at least of a purpose if not of a transcendent guiding intelligence – is just not there. The viewer quickly discerns that these oils are not by Thomson.

His naturalist's habit and training help to explain why, in the last spring of his life, he kept such careful records. Somewhere in the back of his mind was a reference point – Dr. Brodie and his extensive biological records. For Thomson, records meant paintings. They made an assertion about external reality – weather, time and place, a species of tree, a kind of light – as well as serving as an expression of his state of mind, and even of the emotions the landscape aroused in him. The external landscape reflected his inner state: he sought harmony with nature and wonder before its moods. Although he had photographed in the park (Figs. 6–7), he would quickly have agreed that his sketched records weren't photographic, but they freshly conveyed the course of the seasons from spring to summer. What he saw was important; it was his diary of a place he loved, where he felt at home – Algonquin Park. Even in this matter, he may have thought of William Brodie.

Thomson and his family would certainly have discussed Brodie and his collections. Thomson would have known about the 20,000 entomological specimens purchased from Brodie by the Smithsonian Museum in Washington, and the 92,500 specimens of Ontario flora and fauna in the Provincial Museum in Toronto – Brodie's

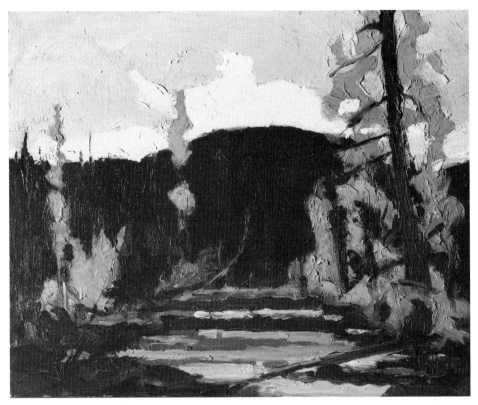

Figure 4
Forger of Tom Thomson
Untitled
Oil on panel
21.0 x 26.7 cm
London Regional Art and Historical Museums,
London, Ontario

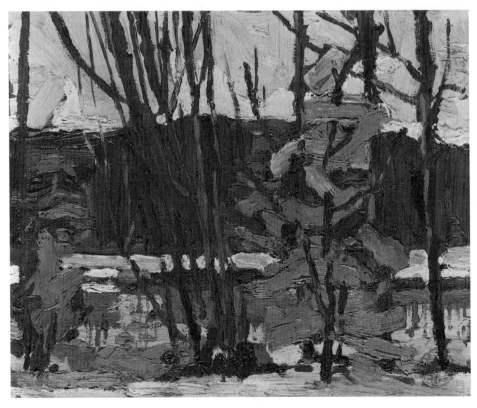

Figure 5
Forger of Tom Thomson
Untitled
Oil on panel
21.5 x 26.7 cm
National Gallery of Canada, Ottawa
Gift of the Douglas M. Duncan Collection, 1970

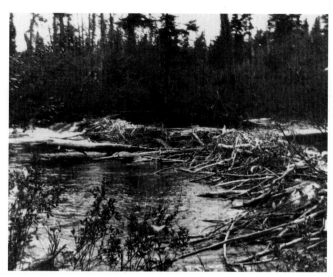

Figure 6
Beaver dam, Algonquin Park
Photograph taken by Tom Thomson. Courtesy of the Tom Thomson Memorial Art Gallery, Owen Sound, Ontario
Private collection, Toronto

Figure 7
Ruffed grouse, Algonquin Park
Photograph taken by Tom Thomson. Courtesy of the Tom Thomson Memorial Art Gallery, Owen Sound, Ontario
Private collection, Toronto

entire collection, with his notes.[13] Thomson would also have seen or heard of Brodie's journal, and he may also have known, or at least hoped, that his own work would some day be seen for what it is – a record of his curiosity about nature and of his awe before it. Perhaps he hoped that in the future someone would seek out his paintings to discover what he had seen in Algonquin Park. That he chose Algonquin Park as a painting site may also be partly due to Brodie.

Brodie's association with Algonquin Park can be traced as far back as 1877, when he founded the Toronto Entomological Society (it changed its name to the Natural History Society of Toronto in 1878). The extensive natural history program carried out by the society led to a clear vision of how quickly the forest and its wildlife were disappearing. The society was instrumental in arguing for the establishment of Algonquin Park in 1893. And Brodie himself was in the park on a trip to collect specimens in 1907.[14] Thomson would have been well informed about his uncle's interests and beliefs. The North would have had a special resonance for him. It rang, however faintly, a bell that said "family."

There is an even more personal reason why Thomson went to Algonquin Park. He was a keen fisherman, as were his friends (Fig. 8): one friend said he and Thomson went to Algonquin Park in 1912 because someone had told them about its beauty and fine fishing.[15] Since he loved to fish, he was often in fishing spots, or liked to think about fishing. He also liked to paint people fishing, or even the fish themselves. *Sufficiency* was the punning title of his early painting of a boy fishing, as if fishing were all one needed to be happy in life. (He reused the sketch later so we know he liked it.) He liked to use the subject both early and late in his work, often stressing the world around the fisherman. The brook trout in Algonquin Park at the time were famous for their size and sweetness. "What he does to those poor fish when he isn't sketching is too awful to relate," Jackson said of Thomson's trout fishing on a trip to the park in 1914.[16] Photographs taken in the park show Thomson standing variously with his catch, fixing bait, or seated on the porch of Mowat Lodge with friends (Figs. 9–11). He took his own photographs of the fish he caught, and even of the reflector oven in which he cooked them. In a sense his

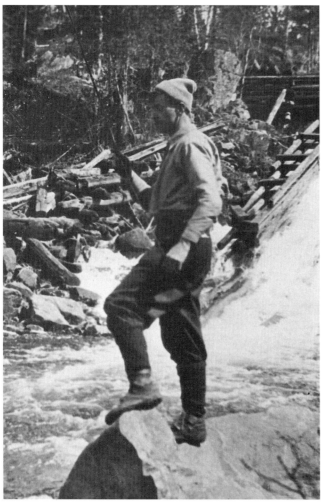

Figure 8
Tom Thomson fishing at Tea Lake Dam, c. 1915 (?)
Photograph taken by Lawren S. Harris. Courtesy of the National Gallery of Canada, Ottawa

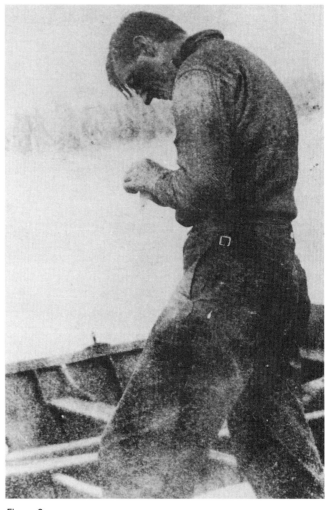

Figure 9
Tom Thomson fixing a fly at Canoe Lake, Algonquin Park, c. 1915
Photograph taken by Maud Varley

progress is an example of a hobby becoming an obsession, in two ways. Painting was his hobby and he became a professional painter; searching for a good fishing spot gave him a world to paint. For him the two went hand in hand. Of course they ran parallel in another way: painting required the same long wait and the same patience as fishing. He spoke of the two with humour. He had painted fishing plugs and got good results catching fish. But occasionally a wily old trout or bass would calmly survey the plug, swim on, survey it from another angle, then swim away. "These fish Tom termed real artists," said Mark Robinson.[17] In April 1917, shortly before he died, Thomson gave up his warden's job because it interfered with his sketching. "I can have a much better time sketching and fishing and be further ahead in the end," he told a relative.[18]

Sadly, Thomson never had a chance to clarify exactly what his series meant to him. Nor did he ever get to see

the sketches in one place. His death, within weeks of his conversation with Robinson, remains a tragic loss for Canadian culture. His friends, who later formed the Group of Seven, had no doubt at the time that they had been deprived of a genius, and future generations have agreed, feeling his death as an almost personal loss.

The sketches themselves were scattered. Thomson's father took them home with him from Mowat Lodge, the hotel in Algonquin Park where Thomson had stayed. "Tom's brother and sisters got most of them," Mark Robinson recalled later.[19]

To reconstruct the work Thomson painted that spring and summer is not easy, but we have one useful clue: as a group, most of them do not have the Tom Thomson estate stamp, a small palette with the initials "TT" and "1917," devised by his friends as a mark of authenticity and used on the sketches he left in his studio in Toronto. There is also a characteristic size to some of the work of this season. Thomson's chronic lack of money that year affected his choice of materials. He had given up the park warden's job, and though he planned to work as a guide and had acquired a guide's licence in April (see Appendix I, page 91), he seems to have earned only a few dollars. He may have been short of painting supplies, since sometimes he used the backs of oil sketches as a sort of notebook, drawing trees or birds on them and adding colour notes. To this season I date as well a number of 11.8 x 17.2 cm panels whose wood seems to have come from the crates for Gold Medal Purity flour and possibly California oranges: fragments of these product names appear on the backs, as in *Birches* and *An Ice Covered Lake* (Pls. 7 and 8). I was also helped in dating sketches of this season by the notes of Dr. J.M. MacCallum, Thomson's friend and patron: he and other friends such as A.Y. Jackson jotted dates on the backs of some of the works.[20]

The series, as Thomson told Robinson, showed the progress of the spring and summer. Thomson arrived at the end of March to find snow on the ground and ice on the lakes. Then the snow melted, revealing slowly growing patches of mud. The ice broke up and the creeks began to flow. The weather varied. It was mostly cold and wet, but in April and May Thomson wrote to MacCallum that the weather had been warm. The sketches he painted on these mild days were few, since often in good weather he worked at jobs such as putting in vegetable gardens for local residents. In the sketches we see mostly scenes of wintry to spring-like skies and partially frozen lakes. The land still looks sombre and cold; the days were grey. A day or so before his death, Thomson wrote, "the weather has been wet and cold all spring."[21]

On the back of one sketch painted this season, *Tea Lake Dam* (Pl. 19), MacCallum recorded that it was of "a thundercloud at the chute." He noted that "the rush of the water and the feeling of daylight is very marked as well as the feeling of spring." He went on to record that "in the trees or bushes in foreground on right side of creek I found a poachers bag with Beaverskins & c. [etc.] – sketched just before his drowning." On the back of the sketch are three drawings of a bird. MacCallum may have recorded the note so carefully because one version of Thomson's death had it that Thomson was killed by poachers. MacCallum may have wanted to provide evidence that poachers were in the park when he was there.

For some, Thomson's sketches of this spring seem repetitive, and had he lived he no doubt would have scraped off and reused more of the boards, as he seems to have done with the sketch in Plate 26. Many of the works that I have dated 1917 are sky studies, with simple, note-like indications of land. I include in this group his magical and luminous sketches of the northern lights, mostly because friends such as Robinson recalled he painted the northern lights that spring (Pls. 25 and 26). Mrs. Daphne Crombie and other informants who were in Algonquin Park at the time helped me identify which northern lights sketches these might be. In a group depicting the spring breakup, Thomson recorded the rapids and the way the water flowed over the rocks or flowed past the bank where he may have sat as he painted (Pls. 22 and 23). *Swift Water* is the appropriate title of one of these: the waters are dark and dynamic, full of splashes and eddies. Thomson also painted the birches by the water, their forms disposed like musical notes in a score, or crossing each other like dancers on a stage. The patterns interlock, at ease with each other, in intricate counterpoint, like

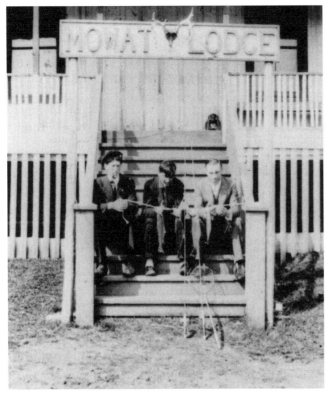

Figure 10
Mowat Lodge, Algonquin Park, 1917
From left to right: J. Shannon Fraser (proprietor), Tom Thomson, and
Charles Robert Edward Robinson
Photograph taken by Mrs. Emily C. Robinson. This copy of photograph courtesy of the
McMichael Canadian Art Collection Archives, Kleinburg, Ontario

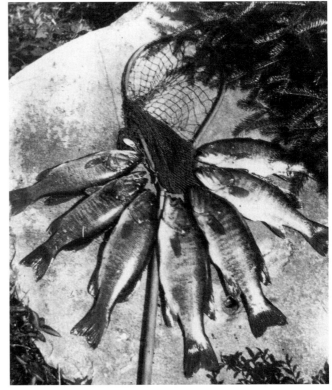

Figure 11
Thomson's catches, Algonquin Park
Photograph taken by Tom Thomson. Courtesy of the Tom Thomson Memorial Art
Gallery, Owen Sound, Ontario
Private collection, Toronto

music made visible. What Thomson perceived in the woods was a space crossed by verticals, often with several diagonals for variety. The result is never claustrophobic; always a touch of sky or lake opens up the view. Thomson disposed of his trees with an unassuming, almost playful charm, but at the same time a sense of authority.

He makes us aware of the snow as it melts. On 21 April, in a letter to MacCallum, he recorded that the snow was "pretty well cleared off."[22] Patches on the north sides of the hills and swamps were all that remained, he said, so now he had to hunt for places to sketch snow. From the evidence of the sketches themselves, the woods were wild, rough, and irregular. Photographs and documents of the period tell us they were burnt over, overgrown, hard to travel through. Snow was one of his favourite subjects, and it helped to clarify, if not create, the design that he needed to paint strong images.

Force compressed in a small framework is a characteristic of his work. Snow, trees, and water are central elements in his vocabulary. Haunting images of wintry woods, bare branches, and cold lakes evoke a grave, disturbing power. In his day Kipling's romantic description of Canada as the "Lady of the Snows" was widely quoted, but Thomson's attitude towards snow was more ambivalent, and based partly on his friendship with Lawren Harris. Harris loved in snow its whiteness, and found in it

a sense of purity which fitted well with his growing interest in esoteric religious matters such as theosophy. Thomson would have been sympathetic to Harris's point of view, but he added a love of colour to the mix of ideas about snow. By reflecting light, snow offers rich and changing possibilities of hue, like a prism. It also provides a textured surface. When painting snow, Thomson usually slathered paint on like creamy icing. His heavy paint build-up offered some relief in a sparse formal repertoire consisting of tree trunks and thinly brushed branches or bushes. *Winter in the Woods* (Pl. 14), the real woods as he found them, is one of his great subjects.

His colour was never less than adventurous. Examining his work in detail, we can now recognize the rightness of decisions that may at the time have looked eccentric. It takes a touch of purple, sombre green, or pink to capture the rapids. Lavender, orange, and pink are essential in spruce and maple, and we welcome trees that unfold like fans. He especially loved the way colours combine to form harmonies – orange, lime, and yellow green in a sunset sky, or the jubilant oranges and reds of the fall forest balanced by shadows of "metal blue," with touches of orange, brown, and "old ivory," colours he recorded on the back of one of the spring sketches of 1917 (Pl. 5). In some sketches he used ultramarine and black for the shadows and cobalt blue for water – proof that on at least a few of his days there was brilliant sun. In the matter of colour he was guided by the enthusiasm of his friend and mentor J.E.H. MacDonald for the work of Vincent Van Gogh. The Dutch painter had used complementary colours such as red and green to bold effect. He drew upon the work of the chemist Michel Eugène Chevreul (1786–1889), whose study of optics had proven so important to the Gobelins tapestry factory in France. Now, in distant Canada, Chevreul's colour theory could be seen in Thomson's practice of contrasting colours of all kinds. Yet he balanced what he had heard with a study of nature. The colour he used this season was also rich, though not as gaudy as in sketches he had painted the previous fall: he now preferred an effect of subtle nuance and a more delicate harmony, perhaps in reaction to the weather. He painted the holes in the thawing snowbanks

with blue, black, brown, and lavender, the shadows of the trees with grey-blue (for the trees he used green). He juxtaposed these colours with the creamy grey, green, and lavender of the snow and the pale grey of distant hills. MacCallum wrote to him that he quite understood that Thomson preferred Algonquin Park to Georgian Bay (where MacCallum had his cottage) for the "brilliant colour from the vegetation" (see the letter of 28 May 1917, in Appendix I). He should have added "and from the snow."

These sketches, through their repeated illumination of a natural landscape (we rarely see figures, and where they do appear they are usually distant), suggest that Thomson recorded a world that echoed the isolation he himself felt. We can see the work as part of the turmoil of the war years. He shared much with the culture of that period: the desire to seek out, and find salvation in, a vast and seemingly uninhabited place. He attempted to create an image of space that was also an image of the spirit – the spirit purified, stripped bare. He possibly, and his friends certainly, thought of his work as an almost archival record of a wilderness area which they called the North Country. Their belief in the importance of this process of reporting and recording was tied to a complex new humanism that emphasized the development of self-knowledge through the experience of nature. Thomson's collected images of Algonquin Park were his treasure, his spiritual storehouse, his gift to the future.

In *Landscape and Ideology*, Ann Bermingham explains why at certain historical moments landscape painting expresses the needs of a whole culture.[23] She speaks of the enclosure of the English countryside as a crucial element in the English Rustic painting tradition from 1740 to 1860. Perhaps Thomson fell upon the imagery of Algonquin Park so avidly because the park was "newly enclosed." The more than five thousand square kilometres of forest, lake, and river had been set aside in 1893 as a conservation area. The land was not enclosed for livestock, as in England, but to preserve a wilderness area; here, enclosure meant not to "drive people off common land" but to preserve it for their use. Ironically, the English enclosures, by enclosing (i.e., privatizing) the

commons (or wild lands) and turning them into agrarian pasture, were responsible for excluding the common people. Algonquin Park, by contrast, enclosed a wilderness area so that it was accessible to people in perpetuity. Bermingham argues that the rustic landscape allows what is erased (here, open land) "still to stand as an informing presence."[24] Paradoxically, the closing of Algonquin Park allowed it to continue to signify wilderness. In this defined space Thomson could shape a new imagery. It was to become, through his imagination and that of his audience, the raw material for our collective image of a mythic landscape.

Reflecting on the general absence of people in Thomson's landscape, Jonathan Bordo, professor of cultural studies at Trent University in Peterborough, has pointed out that an unshaped landscape is at the centre of the project.[25] Bordo feels that the elimination of human presence from the Canadian landscape image is intimately related to the idea of a wilderness as a space:

> Where the image was treated as grounded in the natural object, so here the "wilderness" is considered as something that is already there, a prior state of nature … that predates and continues to survive human occupancy, uninhabited and trackless. But the wilderness is itself a cultural construct that becomes prominent in North America and Europe coincidentally with the modernist landscape aesthetic. Indeed it is not just casually coincidental … the artists were not depicting the wilderness in accordance with the nineteenth century genre of lands and people but rather were symbolic agents for the articulation of the wilderness as an elevated cultural value.[26]

In interpreting what he saw, Thomson seems to me less a realist than a visionary; he constructed symbols out of lived experience. He saw the land as generating a definite emotional rhythm, and he tried to convey what he felt. He was an "environmentalist" who never knew the word. It is his work that for many has become the touch-

stone of our collective idea of natural beauty. Along with Victorian painters such as Lucius O'Brien and John Fraser, Thomson helped formulate Canadian society's spiritual engagement with nature.

Within the silent spaces he recorded, Thomson found that the snow, of which he wrote in a letter to his father on 16 April, interested him more than anything else in the world. He meant the drama of the winter season, as it was played out in a setting of trees, branches, bushes, and land, where light and shadow offered boundaries to the stage set.

Yet if he thought of the park as a stage, we know something else about him: he was lonely. A drama cries out for an audience. Thomson wanted companionship and often wrote friends to ask when they would visit. Dr. MacCallum did come, as we know from his note on the back of a sketch, and Thomson painted *Tea Lake Dam* (Pl. 19), one of his finest sketches, on a trip with the doctor, as though to show him what he could do. In other pre-1917 works, he overtly quoted from the work of painter friends, suggesting that he was thinking of his colleagues as he painted. He often quoted a key motif of A.Y. Jackson – the way a tree from the viewer's space seems to cast a shadow in the foreground of the picture. In several works of 1916 he used separate strokes or clean-cut "dots" which perhaps recalled to him what Jackson had told him about Impressionism and Pointillism (Fig. 12).

Thomson's most earnest desire was to represent the North Country as nothing but itself, in a way unusual at the time, without the embellishments of the Picturesque tradition which characteristically sought grandeur in scenery. The record required close observation and care, two great virtues of his work. Another virtue is that he chose to paint scenes we might easily have overlooked or ignored. Besides this, his works are small. Their size and intimate scale lead to a sense of complicity with their audience, and acknowledge the spectator's freedom to ignore them. It's pleasure-oriented work, earth art, to borrow a phrase often applied to contemporary sculpture. In contemporary art a love for, and insight into, visual reality has been restored to a position of value in pictorial and spatial experience. That helps explain why Thomson's

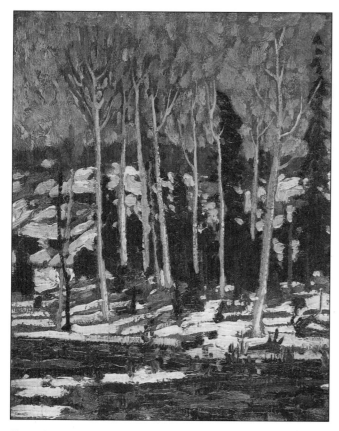

Figure 12
March, 1916
Oil on wooden panel
26.9 x 21.4 cm
National Gallery of Canada, Ottawa
Bequest of Dr. J.M. MacCallum, Toronto, 1944

demonstrate that he went to the earth not to hide, but to reclaim kinship. In the way of a true guide who is not only knowledgeable and wise but eloquent, these sketches keenly evoke an unusual place. They have a crispness, a brevity, and most of all, a firmly resolved focus; their quality suggests that through them Thomson was gearing up to say more, to attempt more. After all, he had, that winter in Toronto, painted *The Jack Pine*. Works like this had given him confidence. Now his painting hand had a new lightness. He commonly dragged paint lightly, to give the merest indication of branches, trees, or splashes of water. And he let the surface of the wooden board show through – let the material work for him. He was in his element, painting at his best. His hour had come. As Lawren Harris said, "His last summer saw him produce his finest work."[27] Even the use of a series, the idea of art as a process with an inevitable succession, shows us that Thomson had begun to think more of the future – his future.

There are other signs in the work that he expected these sketches to take him somewhere. In several brilliantly conceived works he chose to see the view from a height; the result is a panorama, unusual in his work. Where was he going? What was he coming to?

No doubt he was trying to put the place in perspective. Keeping a day-by-day record was an expression of the same impulse. Perhaps he wanted to record the park because he thought of leaving it and painting elsewhere, possibly in the Rockies, as he told a brother-in-law; or perhaps he thought of marrying, which probably would have meant disruption and another sort of leaving. For the fullness of his art, he was seeking to find himself. Perhaps in the process, he thought of William Brodie, the man who had made such a difference to him as a youth. After years of being at sea over what he was to do with his life, he had developed a sense of purpose. It made him remember why he was on earth. We'll never know what he finally intended, but this series of extraordinarily vivid images gives us the happy illusion of being with him in Algonquin Park during his last miraculous springtime.

work, though always valued, increasingly appeals to today's sensibility. That is why artists today look upon Thomson as a hero and an inspiration – and it is what the public has long responded to, instinctively, in his work. What is involved in this response is a revision of what Modernist painting entails. Post-Modernism has brought an increased appetite for representational imagery, and particularly for painters who understand the importance of the natural world.

The land, its moods, the times of day and year, had become part of Thomson's life. The sketches he painted during the last season of his life resonate with a feeling for the authentic shape of the land. The subjects he chose

CHAPTER TWO

The Landscape of His Childhood and Youth;
His Adventures in Seattle

Thomson's art has always been something of a mystery. The paintings seem to have come out of nowhere; certainly his amateurish early work offered no hint of what was to come. His best work is an unusual mixture of gorgeous colour, newly minted imagery, and remarkable sections of passionately applied paint. He painted like an angry man, almost as if he had to make up for lost time, with what look like abrupt gestures. He started his career as an artist late in life, when he was thirty-five, and this may have given him a sense of urgency. Whatever the impulses behind his work, his painting was at once impetuous, decisive, unflinching, and unafraid.

Thomson grew up with one landscape, the rural; then he embraced the urban, in Seattle and Toronto. He was soon to discover yet another world, which suited him far better. He chose Algonquin Park, and to understand the results of that decision, we must balance our knowledge of the landscape of his childhood and youth with his motive for making the North *his* land.

He was born on 5 August 1877, in the town of Claremont in Pickering Township, just east of what is now Metropolitan Toronto. He was the grandson of Scottish immigrants. His grandfather, Thomas Thomson, after whom Thomson was named, and his wife, Elizabeth Brodie, had known one another in St. Fergus, Aberdeenshire, Scotland, before they came over, along with her brother James. James settled in the Whitchurch-Stouffville area; the young couple, after their marriage in 1839, settled in the township of Whitby, where their son John was born in 1840, then moved nearby to Claremont. The area was the focus of their activities for several years.

John was educated in Whitby, at the well-respected grammar school. It was in Claremont that he married Margaret Mathieson from Prince Edward Island, and established his home. This was found to be too small by the time Tom was born, the sixth of ten children. When he was two months old, the family moved to a distant part of Ontario: their Rose Hill farm was near Leith, a summer colony for Owen Sound, eleven kilometres from the town centre. Leith was tiny; Owen Sound, by contrast, boasted a population of nearly seven thousand in 1891, when Thomson was growing up. By 1911 the population numbered nearly thirteen thousand.

Rose Hill farm can still be visited, though both the barn and the house have been renovated (Fig. 13). Thomson liked to sketch the McKeen family farm across the way, and it looks much as it used to, though a room has been added and the surrounding trees have grown. Thomson's home is close to the heart of Leith, a town which mixed the rural and the resort. Leith sits on the

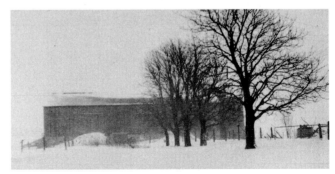

Figure 13
Barn, Rose Hill
National Archives of Canada, Ottawa
(C27 123)

Nipissing Bluff, a pre-glacial shoreline, and from his home Thomson could see Georgian Bay in the near distance. In Thomson's boyhood, electricity and the telephone were still in the future (they came in 1908). From his family Tom learned a love of fishing and hunting. Telfer Creek, which runs through Leith, is famous for its trout and was his favourite fishing stream. Then, as now, the Owen Sound area was one of the most beautiful sections of Ontario. A souvenir pamphlet engraved and printed by Grip Limited, Toronto (where Thomson started work in 1908), boasted that the "driveways and streams" were "unsurpassed." The town itself was "well equipped with all modern conveniences, whilst its palatial homes give an evidence of the taste and wealth of its citizens."[1] A later Thomson family home in the town itself shows quiet and conventional good taste (Fig. 14).

As a city, Owen Sound anticipated great future prosperity, since its excellent harbour handled ships carrying western wheat to eastern Canada; however, these hopes ended when the Canadian Pacific Railway left the town in 1910. Its grain elevators, towering above the harbour and indicating the importance of the town in transporting western crops, were burned in 1907. After such losses the town went into a deep sleep from which it is only just emerging. "Never a Boom but a Steady Growth," Thomson wrote on a seal he designed for the town in 1910; prior to that date the phrase might have been the town motto.[2] Certainly it indicates the modesty of the people in that time and place – hopeful and quietly enterprising, as was Thomson's family. They did not have much in the way of cash, but their life was rich.

The family was renowned for its hospitality: "'It snowed of meat and drink in that house,' to use Chaucer's words," one friend said.[3] Thomson's father was considered eccentric by some of his neighbours. Unlike them, he did not take farming very seriously: he had been known to plant a field of turnips and then, if the fishing was good, simply not bother to harvest them.[4] On his farm was a permanent half acre of garden filled with flowers and herbs. This was the section John Thomson loved best, and he always spoke of gardening as a rewarding hobby. He was a modest student of astronomy and of literature.

He loved to read, and was renowned for his powers of concentration – once he started a book that interested him he would read all night to finish it.[5] He frequented Leith Public Library, which owned the poetry of Burns and Byron (Thomson family favourites) and was delighted by the arrival of anything new. On one occasion he hitched up the carriage and took his wife to town to shop. He went on to the library, found a book he had particularly wanted, and went straight home to read it. When his daughter asked where his mother was, he said, "Did I take her to town?"[6] Photographs show him holding a book with a finger tucked in its pages, as if he had interrupted his reading only long enough for the picture to be taken (Fig. 15). He looks abstracted. He was a dreamer, but a dreamer with a certain authority.

His third son, Tom, took after him in appearance and character (Fig. 16). A.Y. Jackson recalled Thomson reading all night. A friend believed that the ability to concentrate, when he liked what he was doing, accounted for the sudden acceleration in his career.[7] He also demonstrated an independent mind. Such indications as we have of his reading (he told relatives that he liked poetry), his visits to a Toronto discussion group exploring cultural and spiritual matters, and especially his later work, all suggest that although he was not necessarily a penetrating thinker he had all the marks of a man who was searching – for what, he himself may not have

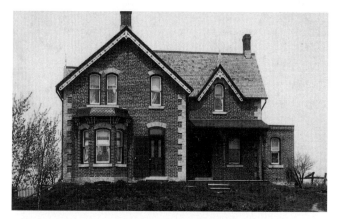

Figure 14
John Thomson home, 8th St. East, Owen Sound
Photograph courtesy of the Grey–Owen Sound Museum, Owen Sound

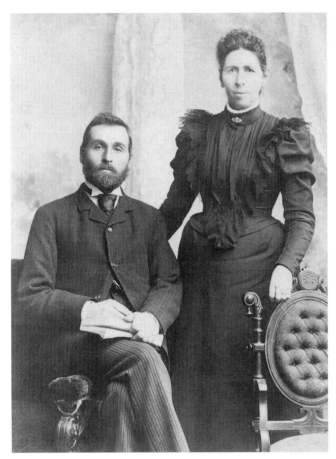

Figure 15
John and Margaret Thomson, Tom Thomson's parents, c. 1890

Figure 16
Tom Thomson, c. 1905

known.[8] He once quoted from Henry Van Dyke's "The Foot Path of Peace" in a pen illustration. His selection indicates his taste and love of nature – "God's out-of-doors" (Fig. 17). No doubt he urged himself, as in Van Dyke's somewhat maudlin prose,

> To be glad of life because it gives you a chance to love, and to work and to play, and to look up at the stars; to be satisfied with your possessions but not contented with yourself until you have made the best use of them; to despise nothing in the world except falsehood and meanness, and to fear nothing except cowardice; to be governed by your admirations rather than your disgusts; to covet nothing that is your neighbour's except his kindness of heart and gentleness of manners; to think seldom of your enemies, often of your friends and every day of Christ, and to spend as much time as you can with body and with spirit in God's out-of-doors. These are little guide posts on the Foot Path of Peace.

Like so many young men of the time, Thomson had a fierce sense of duty. He felt "accountable," responsible for himself, and he understood that determining his path in life meant a price had to be paid. He illustrated the words of

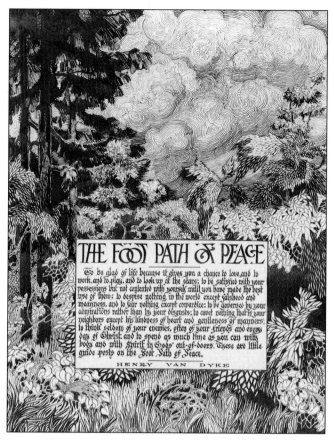

Figure 17
Illustration of a quotation from Henry Van Dyke
The Foot Path of Peace (1914–15)
Pen on vellum
21.75 x 28.25 cm
Private collection, Toronto

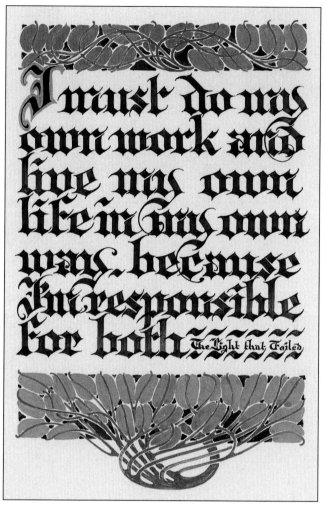

Figure 18
Illustration of a quotation from Rudyard Kipling, 1916
Gouache and ink on paper
26.25 x 18.12 cm
Private collection, Ottawa

Dick Heldar, the painter hero of Rudyard Kipling's *The Light That Failed* (1891): "I must do my own work and live my own life in my own way because I'm responsible for both" (Fig. 18).[9] The words are a little sad, and at the same time provocative. In quoting them Thomson could have been defending his singular ways. He may have been discouraged because he found that sales were few, and grew even fewer when the First World War turned public attention away from such matters as art. Suggestions were no doubt made that he find himself a "real" job. A friend remembered standing beside Thomson, watching a parade of men in uniform. Thomson was truly upset by what the men were going to, although he was by no means a pacifist.[10]

As a young man he had the self-absorbed gaze of the narcissist. He was a bow-tie man, a person with decided opinions and a particular (some say more discriminating) attitude towards life. With his hair parted in the middle and with a lock hanging over his right eye, his shapely dark brows, slightly aquiline nose, and sensitive lips, he

was undoubtedly handsome. He liked to dress in the fashion of the day, which in 1912 meant silk shirts with a loud pattern, pegtop pants, and "dude's shoes." He liked to put his thumbs in his vest to show how smart he felt. He favoured broad-brimmed hats. In Algonquin Park he dressed differently: caps, a jacket, rougher shirts and pants. His face changes in the photographs or sketches we have: in one he looks handsome, in another he smiles and his dimples show, in yet another he is serious, smoking a pipe (Fig. 19). Or he's been fishing, and shows off his big catch. With the ladies, he looks expansive, relaxed (Fig. 20). They found him attractive. "I would have married him in a second," said one who knew him, "but he wasn't the marrying kind."[11]

Among his family he was known for his generosity and his wry sense of humour. He was fun to be with; he loved exercise, activity of any kind, hunting and fishing. On the back of one sketch of 1915, Dr. James MacCallum wrote, "On this day Thomson tramped fourteen miles carrying a sketch box and gun – a fox and seven partridge which he shot that day and did this and another sketch."[12] A.Y. Jackson recalled that Thomson paddled on their canoe trips while Jackson sat in the bottom of the canoe and kept a sharp eye for motifs.[13] In Toronto, said Lawren Harris, Thomson would snowshoe the length of the Rosedale ravine, then out into the country and back.[14] Harris also remembered him sleeping on fine nights in Algonquin Park in the bottom of his canoe out on the

Figure 20
Photograph of *Tom and Gals*, Toronto (?), c. 1908
Art Gallery of Peel, Brampton
Gift of Robert and Betty Bull, 1993

lake. Others describe Thomson in action: dancing, jumping, kicking on the electric light switch that hung by a cord in his shack, running.[15] He was graceful.

He was also handy; he could fix things. He didn't mind helping out. In the shack in Toronto where he lived, he built himself a bunk, shelves, a table, an easel. He liked to cook, especially pancakes. He made his own fishing trolls from piano wire, coloured beads, five-cent pieces, buttons, and bits of painted wood. He made beads, and hammered out pieces of metal that were works of art in themselves.[16] He could mend torn canvas.[17] Varley's wife, Maud, remembered that Thomson had advised her on the colour for the trim of a dress she was making.[18] He had a lovable nature.[19] In psychological terms, he was a "pleaser," a person who suppresses his personality to satisfy the needs of others. Part of his charm came from his quiet ways. He was always "as plain and easy as an old shoe," a boyhood friend, Alan Ross, said.[20] A typical farm boy, he

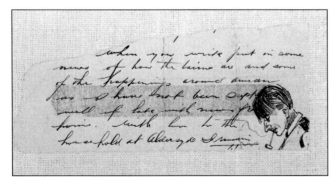

Figure 19
Fragment from a letter from Tom Thomson to a sister's family in Annan, Ontario, in which he asks for news from home, c. 1914
Private collection, Owen Sound

didn't say much. Distance and reserve are also part of the ways of the "pleaser." He may have been diffident from fear of sounding like a fool, but it is also possible that he just liked to listen – after all, he was in the company of champion talkers, such as Jackson, who must have appreciated a good audience. Yet sometimes we wish he hadn't been so non-verbal. His letters convey only bare information, and apparently he said little that was quotable. All we find when we search to discover him is the whiff of an unusual character, like a rare fragrance. He touched the life of many others for a moment, then was gone.

There are reports of his independence, and occasional rudeness, in his youth and during the early years of his professional life. He was critical of authority. He stood up to the Rev. J.B. Fraser (1884–1916), the stern minister of the church in Leith. In one commercial art firm, the boss belittled him as an erratic and difficult man.[21] He had a hot temper, especially if he thought injustice had occurred. He had spells of indolence, aimlessness, vague unhappiness, and depression. When things went wrong, emotions built up inside. He absorbed his anger, and yet later he would erupt. He might have an outburst of words or get drunk, or both.

His family understood him. They knew that he, like them, was a person of artistic temperament; in their household, art was in the blood. They were musically and visually gifted. Nearly everyone played an instrument, sang, or sketched. Tom's brother George played the flute in a brass band which his father helped finance.[22] Thomson himself played the cornet (badly), the mandolin, and possibly the violin, and he had a good tenor voice.[23] Tom's father sketched; his uncle had been good at drawing and so were a number of his siblings, particularly George, his oldest brother and early mentor, though none of them shared Tom's gift.

Illness interrupted Thomson's education in his youth. His weak lungs and a touch of inflammatory rheumatism led to several attacks of congestion; as a result he was kept out of school and spent much of his adolescence out of doors, which extended his intimacy with nature.[24] Given complete freedom, he roamed widely over the Leith area. After school he worked on the farm until 1898. That year,

at the age of twenty-one, he received a legacy of about $2,000 from his grandfather's estate. In 1899 he apprenticed himself to a firm of machinists, Wm. Kennedy and Sons, in Owen Sound. But the work did not agree with him and he left, only to regret the decision later, perhaps because he'd forsaken a steady job. "He seemed to me at the time to be drifting," recalled a friend.[25] He began to travel, first to Winnipeg to work as a harvester, then to Chatham, where he attended business college from 1901 to 1902, then to Seattle in the latter part of 1902 for another spell at business college and his first employment as a commercial artist. He finally settled in Toronto in 1905.

In going to business college, Thomson probably felt he was delaying a decision about a career while keeping his options open. His older brothers had attended business college, and he was following in their footsteps. He may have felt, too, that he needed business college to improve his qualifications. In the primary school he attended in Leith, like other rural schools, the subjects of reading, writing, arithmetic and Latin occupied a prominent place. However, Thomson did not go on to high school, and he probably felt the lack of formal education more and more keenly as he grew up. Business school would help to fill some of the gaps in his education. A course in such a school might run thirteen weeks, twenty-five weeks, or a scholastic year.[26] In 1901, Thomson went to the Canada Business College in Chatham, but it is not known how long he stayed. A Thomas Thompson (sic) is listed in the 1902 Chatham City Directory as a boarder, and there are two watercolours he gave to a woman in Chatham that year.[27] His name did not appear on the honour roll in the school's promotional booklet of 1904, though his brother George ranked seventh.[28] Still, he probably found the all-male school, which stressed practical instruction and penmanship, congenial.[29]

At the school in Chatham, Thomson's older brothers, George and Henry, had become friendly with F.R. McLaren and C.C. Maring, who taught penmanship. McLaren and George Thomson became principals of the Consolidated College Company, later the Acme Business College (Fig. 21) in Seattle, Washington, in 1894–95. No

Acme Business College

SEATTLE ~ WASH.

The School for Results

POSITIONS SECURED FOR GRADUATES

A Bread and Butter Training in Bookkeeping, Shorthand and English.

Business Men Furnished with Office Help Free of Charge.

Write for Catalogue or call.

Chapin Bldg,
S E Cor Second Ave.
and Pike St.

F. R. McLaren
Geo. Thomson, LL. B.

PRINCIPALS.

Figure 21
Advertisement for Acme Business College, *Seattle City Directory*, 1903, p. 31
Photograph courtesy of the Seattle Historical Society, Museum of History and Industry, Seattle

Figure 22
The Chapin Building, southeast corner of Second and Pike streets, Seattle, between 1901 and 1906, Second Avenue side. (The second window from the right on the second floor says "Acme Business College.")
Photograph courtesy of the Seattle Historical Society, Museum of History and Industry, Seattle

reads: "As a pupil in the Special Penmanship Department of the Acme Business College, I take pleasure in endorsing the work of this institution" (Fig. 23). On the left is an allegorical figure, possibly Fortuna, holding a shield with the letters ABC inscribed on it. The work suggests what he was learning – how to handle pen and ink.

Thomson stayed at the Acme for only six months, having found employment in the local engraving trade. Doubtless it was to get a job that he drew up a business card for himself as "Tom Thomson Commercial Designs" (Fig. 24). As in his endorsement of the Acme, he drew upon the classical world: Pegasus rises out of a central circle with "T." His obvious flair for handling pen and ink soon brought him work. The *Seattle City Directory* tells us that in 1902 he started with the engraving firm of Maring & Ladd (later Maring & Blake), run by C.C. Maring, his brother George's old friend from Chatham (Fig. 25). In 1904 Thomson was enticed away by an offer of ten dollars a week more from the Seattle Engraving Company.[31]

The engraving trade that employed Thomson for the next decade was in its infancy. Maring's daughter said later that Maring & Blake was the first photo-engraving

doubt the Acme was modelled along the lines of the school in Chatham. George Thomson said later that a survey of business colleges around 1904 rated the Acme as the eleventh largest in the United States, though its office in the Chapin Building does not look especially impressive (Fig. 22).[30] Following in his brothers' footsteps, Tom came to Seattle in 1902 to attend. We know he was there in 1902 because of a testimonial he prepared, which

Figure 23
Endorsement, c. 1902

Location unknown

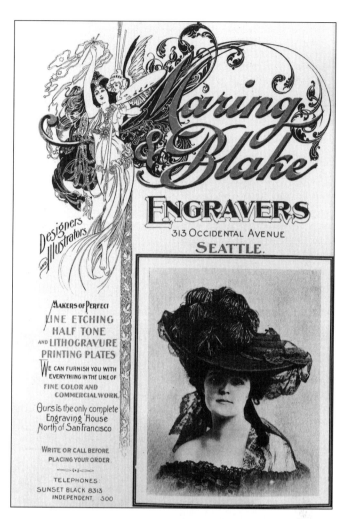

Figure 25
Advertisement for Maring & Blake, *Seattle City Directory*, 1903, p. 806

Photograph courtesy of the Seattle Historical Society, Museum of History & Industry,
Seattle

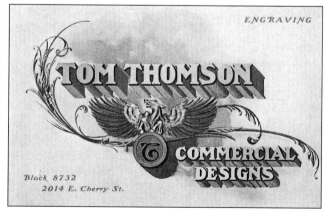

Figure 24
Business card, c. 1902

Private collection, Toronto

plant west of the Mississippi River. As such, it would have had a monopoly on the new process over a large area. Such companies made printing plates, with some varieties of tone not attainable by any other method. A specialty of Maring & Blake was colour work. The principals of the firm handled different jobs: Maring was the art director; Edgar L. Blake, another Canadian, was a photo-engraver and artist. The firm did advertising work for city directories, among other clients, which required an extensive knowledge of design (Fig. 26).[32] It was in this area that Thomson excelled. Apparently, he always did the work to

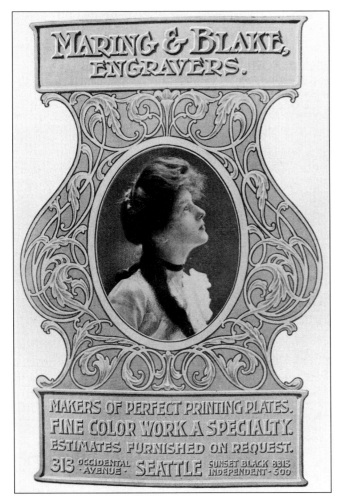

Figure 26
Advertisement for Maring & Blake, *Seattle City Directory*, 1904, p. 715

Photograph courtesy of the Seattle Historical Society, Museum of History & Industry, Seattle

suit his own ideas and not the instructions given by Maring, which, according to a brother, would make Mr. Maring angry.[33]

The nature of Thomson's work at Maring & Blake may be suggested by a sketch of a lady's head, possibly done in their offices (Fraser Thomson records that he picked a sketch of a lady's head out of a waste basket, where Tom had thrown it). This may be the sketch titled *Study of a Woman's Head* that Fraser Thomson gave to the Tom Thomson Memorial Art Gallery in Owen Sound (Fig. 27). Slight, but full of vitality, it depicts a woman with wiry hair curling out of place, her swanlike neck exaggerated by the neckline of her dress. Although it might be a portrait, the work is more likely a version of the Gibson Girl, a subject used often in American art at the time. The image was a pert ideal of American womanhood, developed by Charles Dana Gibson, who often drew his goddess. She became so popular in illustrations that today we think of her as synonymous with the 1900s. Women followed the lead of the magazines and took up the look. Here, the use of pen and ink, combined with crayon, shows us that Thomson had already developed his driving, nervous line. In every flick of the pen there is the energy characteristic of his later brush work. Another sketch, this time drawn from looking at his own image in a mirror or photograph, shows Thomson's wiry pen line. He has inked in so much of his face that he looks peculiarly dark (Fig. 28).

At the Seattle Engraving Company, Thomson

worked in pen and ink, water colour and black and white wash. He was continually looking over the various magazines, giving its [their] advertisements a great deal of study, principally from the standpoint of decoration. It was a regular game with him to pick the best of them, change the design to suit his own ideas – and then compare their respective merits.[34]

An advertisement for the Seattle Engraving Company (from the *Seattle City Directory*) shows the elaborate penmanship of the day. The company employed fifteen

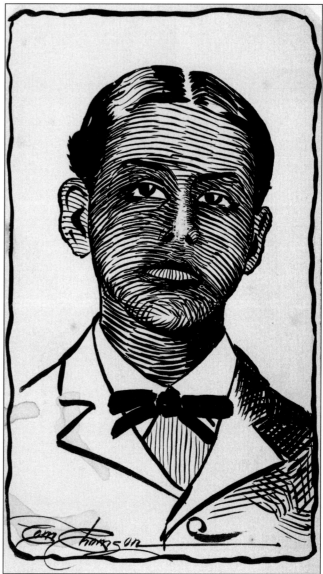

Figure 27
Study of a Woman's Head, c. 1903
Ink and coloured pencil on card
9.25 x 8.75 cm

Tom Thomson Memorial Art Gallery, Owen Sound

Gift of Fraser Thomson

Figure 28
Self Portrait, c. 1905
Found in a sketchbook

Art Gallery of Peel, Brampton

Gift of Robert and Betty Bull, 1993

(Thomson probably drew this from the photograph

reproduced on page 24, Figure 33.)

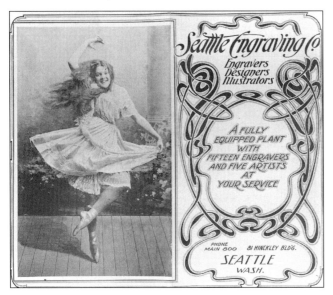

Figure 29
Advertisement for Seattle Engraving Co., *Seattle City Directory*, 1901, p. 1393

Photograph courtesy of the Seattle Historical Society, Museum of History & Industry, Seattle

engravers and five artists "at your service" – nor was it without a sense of humour: note the billboard photograph next to the ad (Fig. 29).

Thomson's way of reusing motifs can be seen if we look at a painting he did of a boy fishing, and compare it with a later sketch of the same dreamy-faced youth, though with a broader brim to his hat (Figs. 30–31). He even used the motif again, but added landscape (Fig. 32). Thomson liked to mine and use his past.

The clue to Thomson's new incisiveness may have been the different world he found in Seattle. We know that when he arrived, in 1901, Seattle was lively and open. In ten years it had more than doubled its population. It had an exotic quality. Of the population of 80,000 in 1900, approximately half were of foreign parentage and a quarter more were foreign born.[35] Thomson, several of his brothers, and his friend Horace Rutherford (1880–1965), who later lived most of his life around Seattle, were part of a group of Owen Sound "Old Boys" who looked out for each other (Figs. 33–34).

In Seattle, Thomson fell in love with Alice Lambert,

the daughter of a minister (Fig. 35). Their romance blossomed in Mrs. Shaw's boarding house, where Thomson's brother Ralph roomed (Ralph later married Mrs. Shaw's daughter Ruth). "I recall him standing by the piano," Alice Lambert wrote,

while Mrs. Shaw, whom I adored as my more than mother – I called her Angel always – played the piano. One of his favourites was "In the shade of the sheltering Palms." He would stand there tall and dark and slender, singing in his high clear tenor, and the other boarders, the family and I would sit around and beg him to sing. One night I fainted, and Tom carried me in his arms up to the third floor bedroom I shared with Ruth.

We knew without words that we loved each other. We used to meet some how or other at noon, he going home to lunch and I taking the James St. Cable car to the power house at the head of the James Street run, Broadway and James, I think it was. We would just meet, say a few brief words, and part.

The last time I saw him, he and I had been looking for a house for my family to move into – it was at Alki Point. The street car stopped a mile away from the settlement on Alki, and we walked hand in hand, seldom speaking, my heart bursting with love – I have never felt toward anyone on earth as I did toward Tom. We had ESP, hardly needing words, and I know he felt the same toward me. For years I have planned to go to wherever he was buried, to lay a red rose on his grave.

The thing that sent him East concerned me. A fellow boarder, I forget his name, told Tom I was engaged to him. Tom packed him up and himself and went East to save me from whoever that was. I used to long to write him, or find him, but a miserable experience prevented me, finally, and I married a man with whom I had no communication whatever. But I have never put him out of

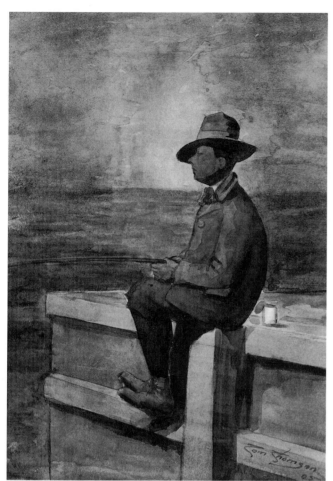

Figure 31
Young Fisherman, c. 1905
Ink on paper
33.3 x 50.8 cm
The McMichael Canadian Art Collection, Kleinburg
Gift of the founders, Robert and Signe McMichael, 1957
(The setting is reminiscent of Telfer's Creek in Leith, Thomson's favourite place to fish.)

Figure 30
Sufficiency, 1905
Oil on board
35 x 25 cm
Private collection, Leith
(Adam Ainslie's dock in Leith may be shown.)

Figure 32
Untitled, 1908
Pen on paper
30.12 x 50 cm
Private collection, Toronto
(The site could be Telfer's Creek in Leith.)

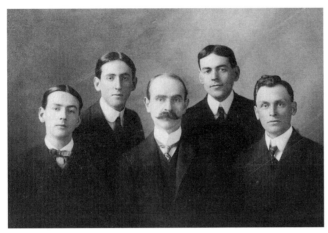

Figure 33
The Thomson brothers and their brother-in-law, c. 1905 (?),
Owen Sound. From left to right: Tom, Ralph, George, Henry, and
Tom Harkness
JM, TTP

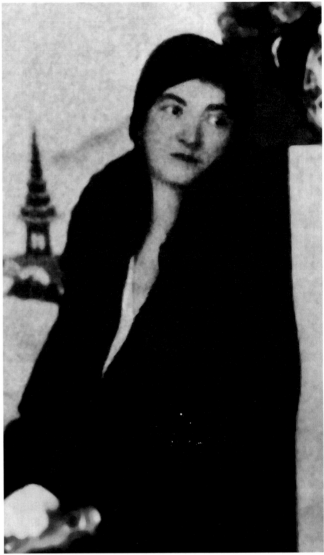

Figure 35
Alice Elinor Lambert, 1933. From a photograph in the *Seattle Times*,
13 August 1933
Photograph courtesy of the Special Collections Division,
University of Washington Libraries, Seattle, Washington
(NW 136–137)

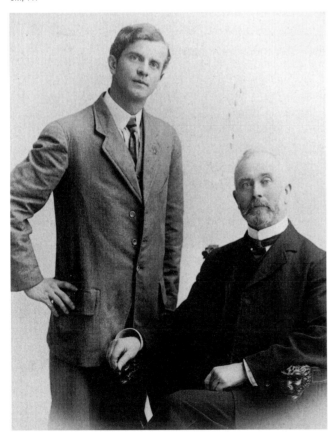

Figure 34
Horace Rutherford and his father, David, c. 1903
Photograph courtesy of D.W. Kibbey, Spokane, Washington

my heart. We were two star crossed young and innocent people who never should have parted.[36]

It's hard to know what happened. The fellow boarder of whom Lambert speaks was Rutherford. Perhaps he and Alice joked that they were going to be married, and Thomson packed up, forcing Rutherford to go with him since he may have known Rutherford was not worthy of Lambert, as she said.

There is another version. Thomson's niece Ruth Wilkins, the daughter of Ralph Thomson and Ruth Shaw, said she heard from her mother, father, Alice, and her grandparents that Thomson left because of an affront to his dignity.[37] Thomson was very shy and Alice effervescent and high-strung. When he proposed, she, in sheer nervousness, giggled. The imagined slight was too much; he got angry and left Seattle, never to return. Whatever the story, the result was the same. Thomson went home, settling in Toronto. Lambert, it should be added, did grieve for a time. She then went on to write Dell romances with titles like *Women Are Like That* (1934), with heroes who break a lady's heart merely by smiling. They were the equivalent of the Harlequin romances of today. Perhaps Thomson considered he had the best of the deal; he may have felt glad he had seized on an excuse to extricate himself from a threatening entanglement. He does not seem to have looked back, and never wrote to her. Much later, in 1914 or 1915, he confided to a friend that he had had two experiences with women, one in Toronto and one in the North. He may not have had such an "experience" with his friend in Seattle.[38]

However, after Seattle, he was careful to avoid any serious romantic commitment. In Toronto, he kept company with women such as Elizabeth McCarnen, but in 1910 she left to raise the orphaned children of two siblings in Phelpston, Ontario. In Algonquin Park he saw others, among them Winifred Trainor, a bookkeeper who lived in Huntsville with her parents. Because her father was a foreman at a lumber camp, the family was at home in the outdoors, maintaining a summer cabin on Canoe Lake. Younger than Thomson by seven years, and handsome, Winifred liked to fish. Two of Thomson's photographs show her standing in a high-necked gingham dress, holding rod and catch. Thomson liked her enough to give her many sketches, but he was generous with everyone. Of the many confusing stories about Thomson at the end of his life, one stands out: Trainor wanted to marry him, and Thomson, as had been the case with Lambert, was getting close to the act, but had developed reservations. By then, he would have realized the advantage in being free, especially for an artist with his scanty earnings.

LIST OF PLATES

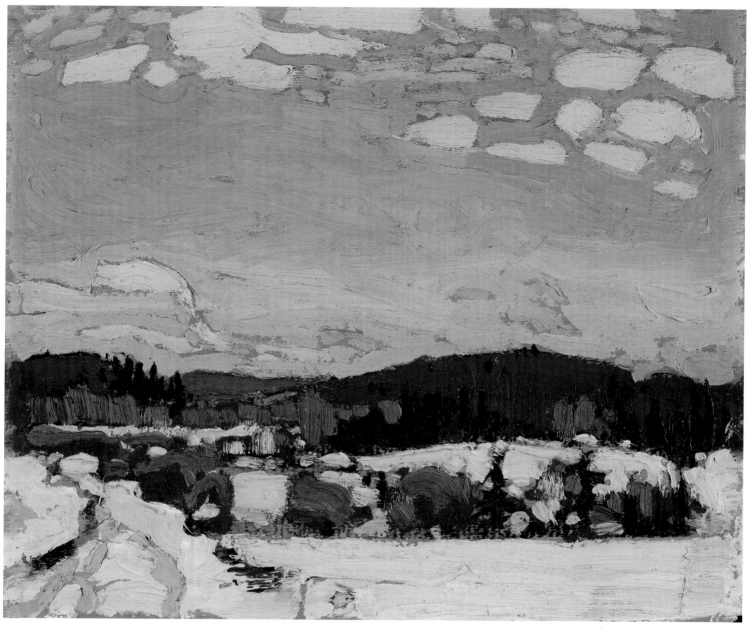

Plate 1. *Early Spring*
Oil on panel
21.6 x 26.7 cm
Art Gallery of Ontario, Toronto
Gift of the Reuben and Kate Leonard Canadian Fund, 1927

On the back of this work MacCallum wrote in pencil, "painted the early spring before Thomson's death."

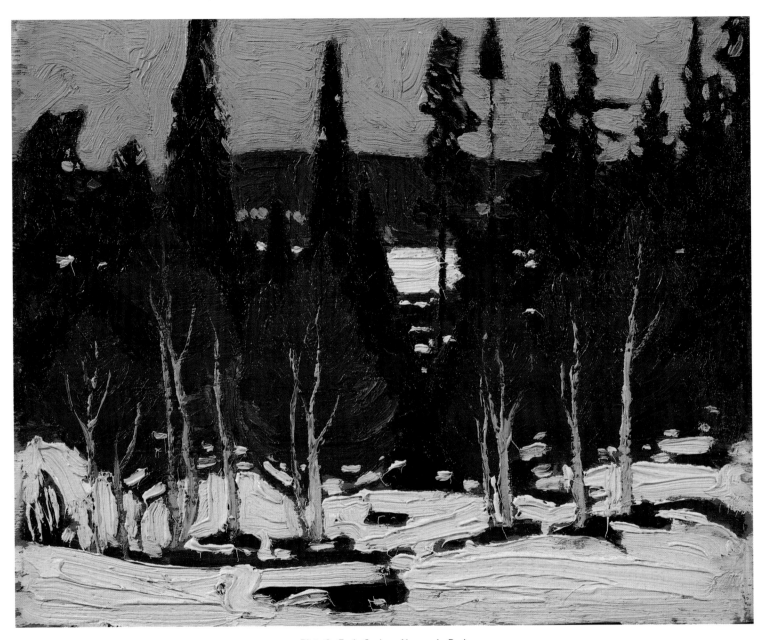

Plate 2. *Early Spring, Algonquin Park*
Oil on board
22.0 x 27.0 cm

Private collection, Montreal

Alice and the Hon. Vincent Massey gave this painting to Sir George and Lady Parkin in April 1920.
(Sir George and Lady Parkin were Alice's parents.)

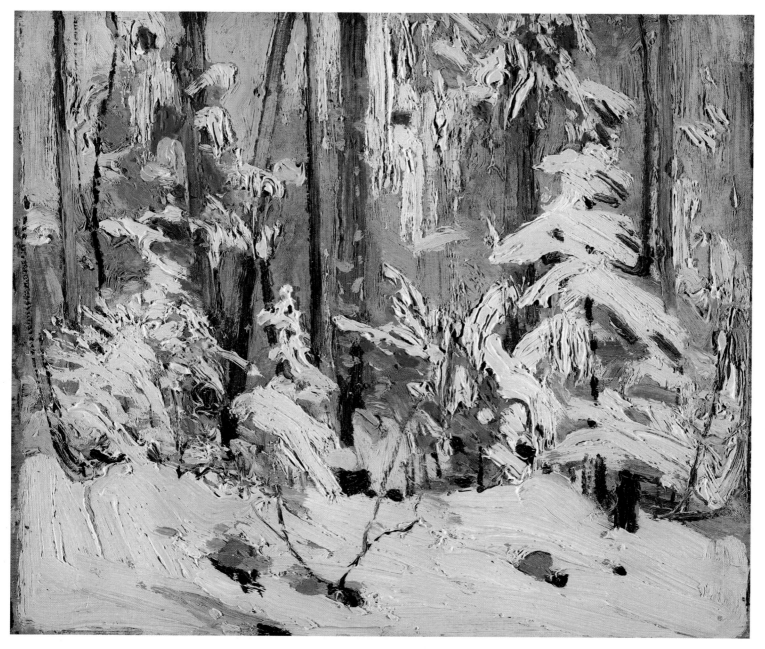

Plate 3. *Wood Interior, Winter*
Oil on panel
21.9 x 26.7 cm
The McMichael Canadian Art Collection, Kleinburg
Gift of Mrs. Margaret Thomson Tweedale

This sketch belonged to Thomson's sister Margaret Tweedale. The fact that it was one of the works that went to Owen Sound after Thomson's death indicates that it was probably made in spring 1917; it also fits stylistically.

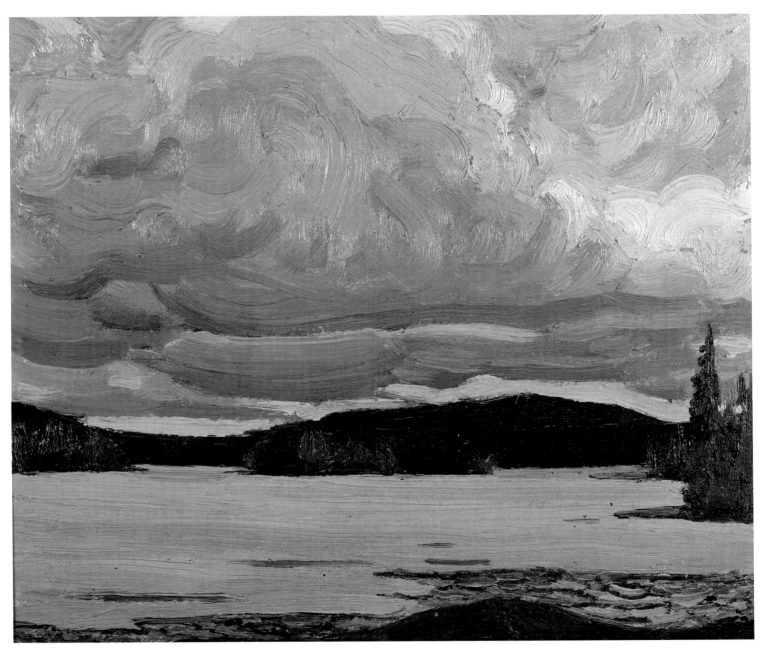

Plate 4. *Canoe Lake*
Oil on board
21.6 x 26.7 cm
Private collection, Calgary

Canoe Lake was one of the sketches Thomson gave Winifred Trainor. I date it to the spring of 1917
because of the wintry sky and icy lake.

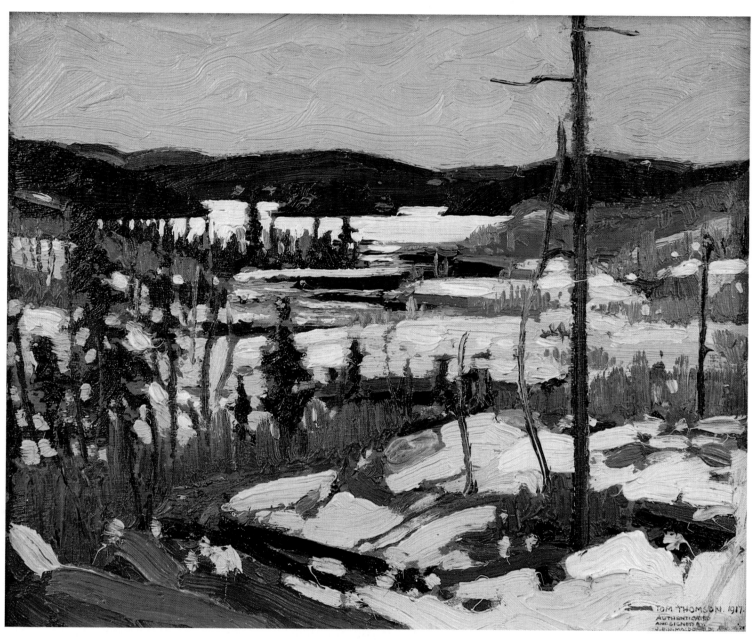

Plate 5. *Early Spring, Canoe Lake*
Oil on panel
21.4 x 26.7 cm
Private collection, London, Ontario

On the verso of this sketch is a drawing of a bird with colour notes: "Metal blue, orange, brown, old ivory." It was owned by J. Shannon Fraser, who ran Mowat Lodge on Canoe Lake where Thomson stayed. In one version of the story, Fraser is supposed to have caused Thomson's death. On the front of the work J.E.H. MacDonald wrote, "Tom Thomson. 1917," which suggests the date.

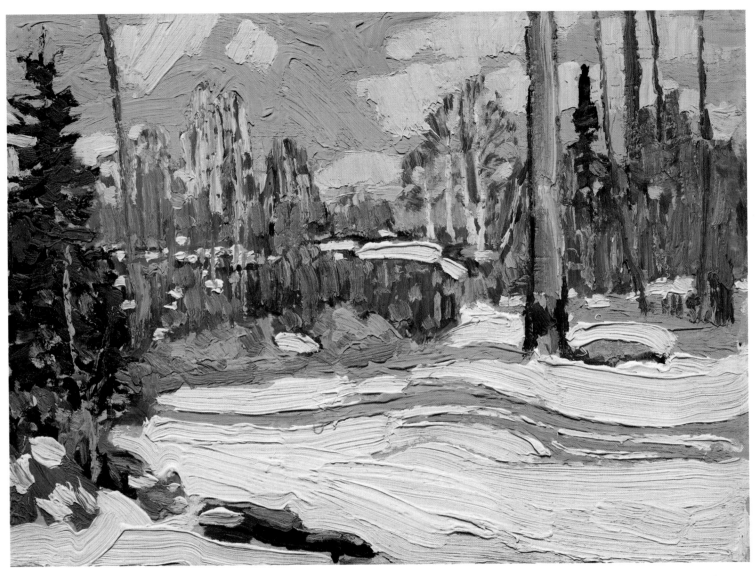

Plate 6. *Woods in Winter*
Oil on panel
14.6 x 20.0 cm
Tom Thomson Memorial Art Gallery, Owen Sound, Ontario
Gift of Mrs. J.G. Henry

This small painting belonged to Thomson's sister Louise Henry. On the back in pencil is written, "Woods in Winter." To make the board, Thomson cut down a bigger panel.

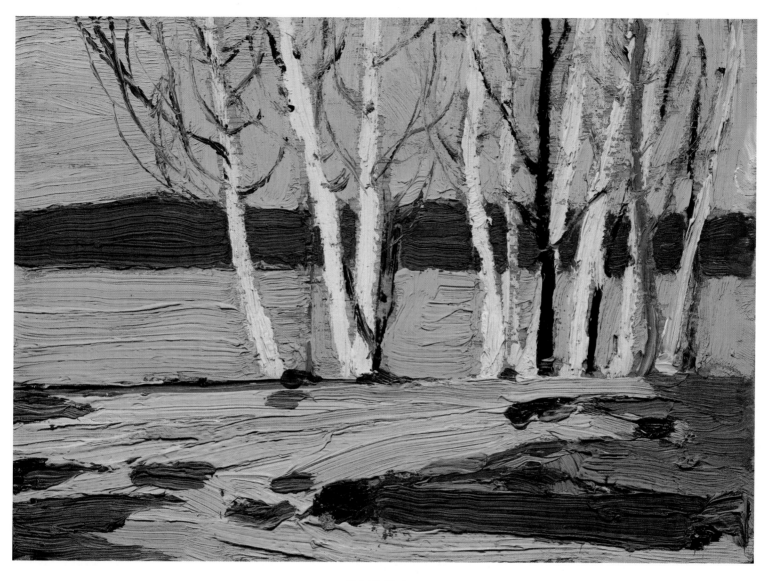

Plate 7. *Birches*
Oil on panel
14.3 x 20.0 cm
Tom Thomson Memorial Art Gallery, Owen Sound, Ontario
Gift of Mrs. J.G. Henry, 1971

On the back are the remains of stamped letters from wooden crates, possibly for Purity flour or oranges.
Thoreau MacDonald, the son of J.E.H. MacDonald, wrote on the back, "In my opinion a good example
of Tom Thomson's work 1916 or 1917." The size and material suggest that it was painted in the
spring of 1917.

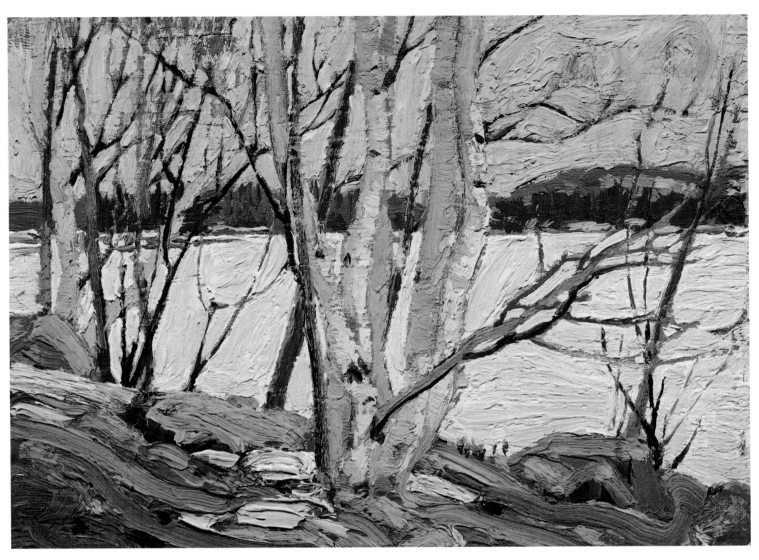

Plate 8. *An Ice Covered Lake*
Oil on panel
13.3 x 19.1 cm

Tom Thomson Memorial Art Gallery, Owen Sound, Ontario

Gift of George Thomson, 1964

On the back of the sketch, Thomson's brother George wrote in pen: "An Ice Covered Lake selected from
Tom Thomson's last group of sketches in the Spring of 1917 by his brother Geo. Thomson." On the
wooden panel remain parts of the words stamped on the original material; one of them is [Calif]"ORNIA."

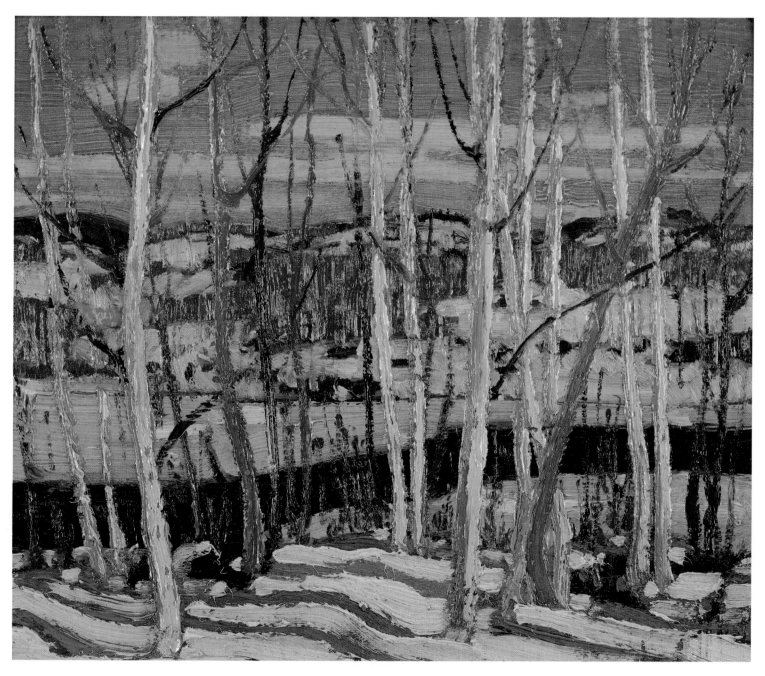

Plate 9. *Open Water, Joe Creek*
Oil on panel
21.3 x 26.7 cm

Ken Thomson, Toronto

On the back, in pen, MacCallum wrote, "Open Water, Joe Creek." The sketch was owned by Barker Fairley,
a professor at the University of Toronto who was, in 1920, in the circle of the Group of Seven
(he later became a painter).

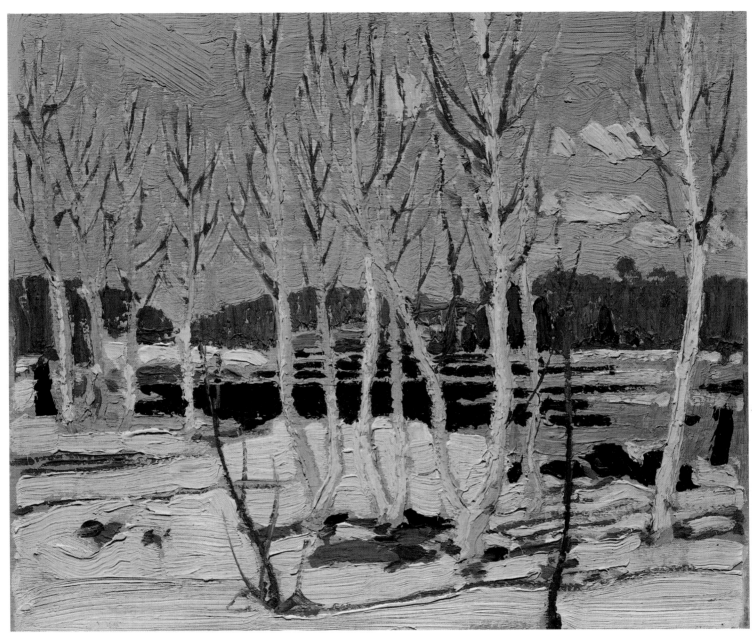

Plate 10. *April in Algonquin Park*
Oil on panel
21.3 x 26.7 cm
Tom Thomson Memorial Art Gallery, Owen Sound, Ontario
Gift of George Thomson, 1964

On the verso Thomson's brother George wrote, "Painted by Tom Thomson 1917, April in Algonquin Park."

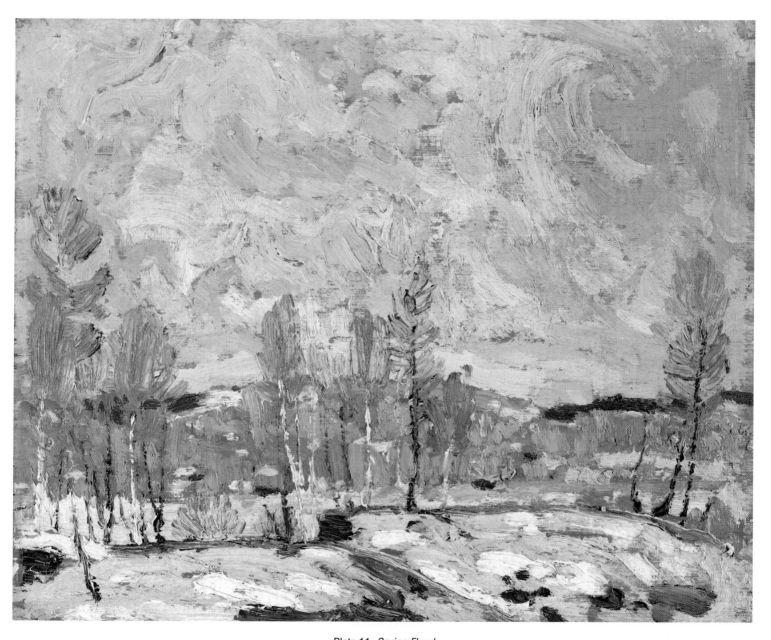

Plate 11. *Spring Flood*
Oil on panel
21.0 x 26.8 cm
The McMichael Canadian Art Collection, Kleinburg
Gift of R.A. Laidlaw, 1966

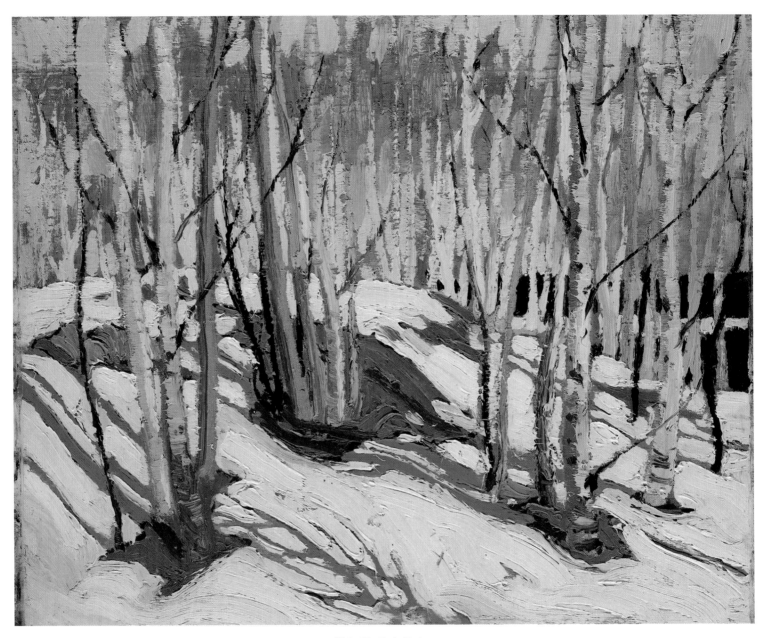

Plate 12. *Early Spring*
Oil on panel
20.9 x 26.7 cm
The McMichael Canadian Art Collection, Kleinburg
Gift of Margaret Thomson Tweedale

"We still have a foot or two of snow on the north side of the hills ..."
– Thomson to Tom Harkness, 23 (?) April 1917

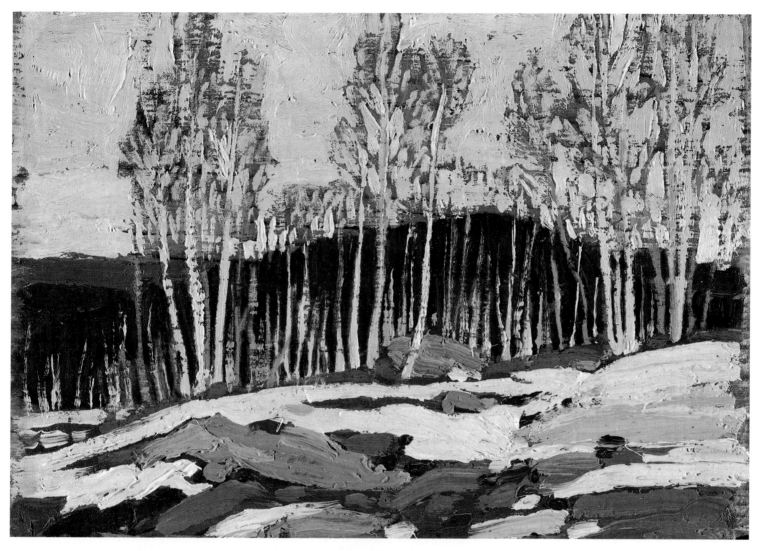

Plate 13. *Birches*
Oil on panel
12.9 x 18.7 cm

The McMichael Canadian Art Collection, Kleinburg

Purchase, 1979

On the verso is written in pen: "Property of / Mr. & Mrs. Geo. M. Thomson Dec/1917 / One of the two
sketches sent / to me by Grandfather, / among the sketches left by / Tom Thomson at his / death in 1917.
G.W. Thomson"; in pencil is written: "Northern Sunset by Tom T."

39

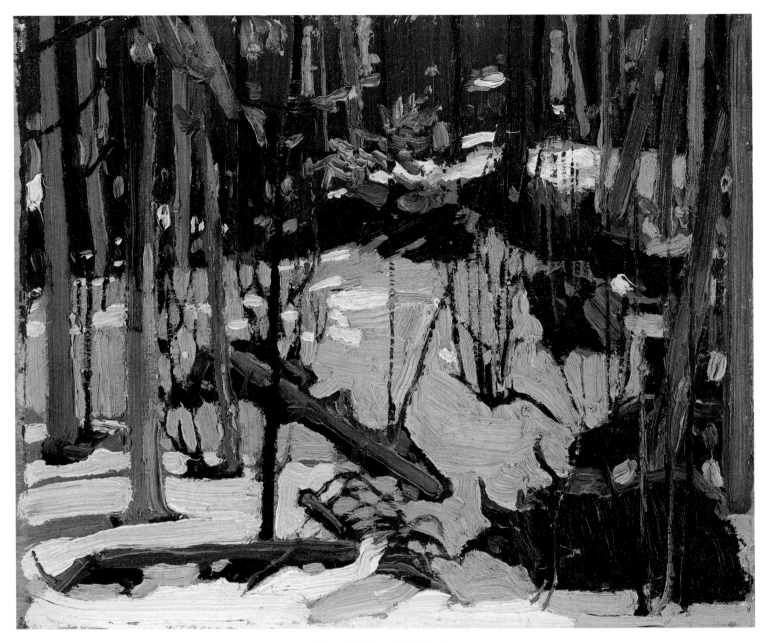

Plate 14. *Winter in the Woods*
Oil on panel
21.4 x 26.5 cm
National Gallery of Canada, Ottawa
Bequest of Dr. J.M. MacCallum, Toronto, 1944

On a label on the back MacCallum wrote, "Wood Interior – Winter."

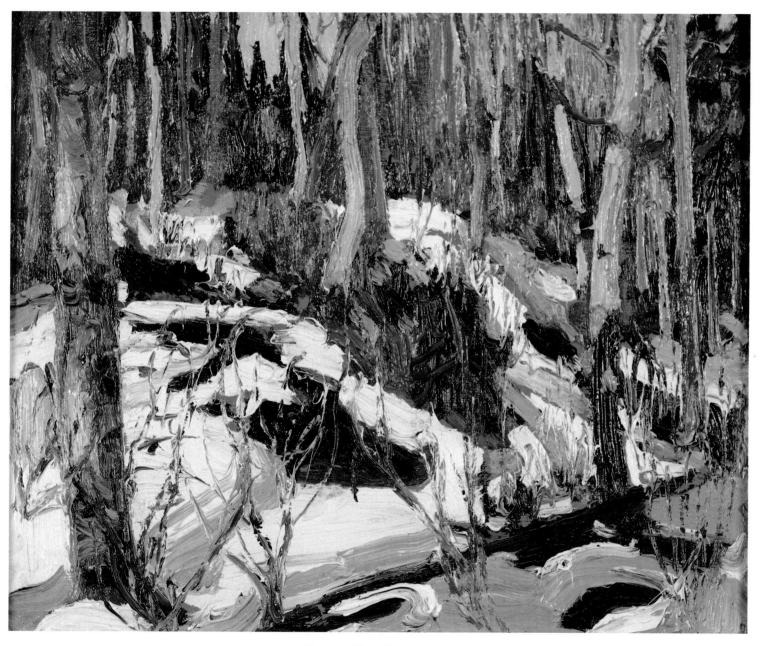

Plate 15. *Winter Thaw in Woods*
Oil on board
21.6 x 26.7 cm
Ken Thomson, Toronto

William J. Ard, who owned the general store in South River where Thomson bought supplies, acquired
this sketch from the artist for $25 (see the letter MacCallum wrote Thomson, 28 May 1917).
On the back in pencil is William J. Ard's name and address.

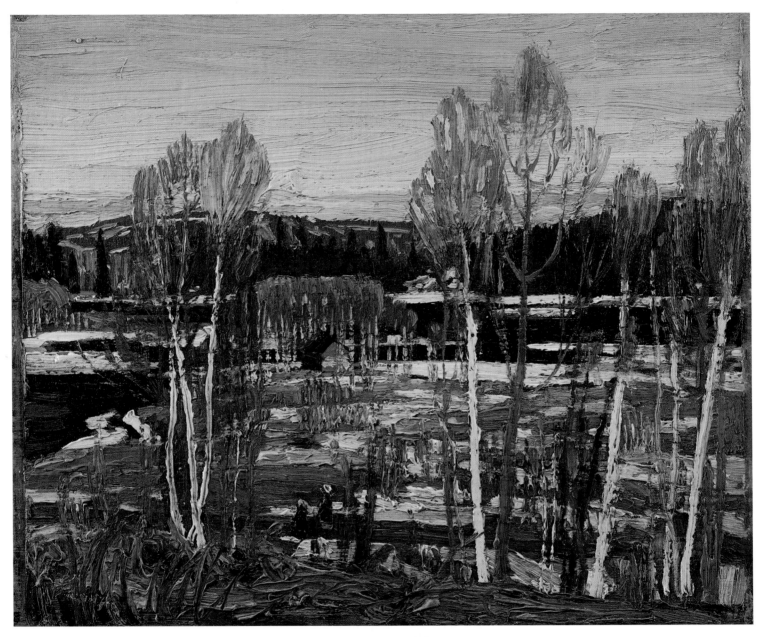

Plate 16. *The Artist's Hut*
Oil on panel
21.3 x 26.6 cm
National Gallery of Canada, Ottawa
Purchase, 1918

Mrs. Crombie said that she and Annie Fraser, Shannon Fraser's wife, appeared in this sketch. The hut in the distance was the one in which Thomson kept warm while painting the northern lights.

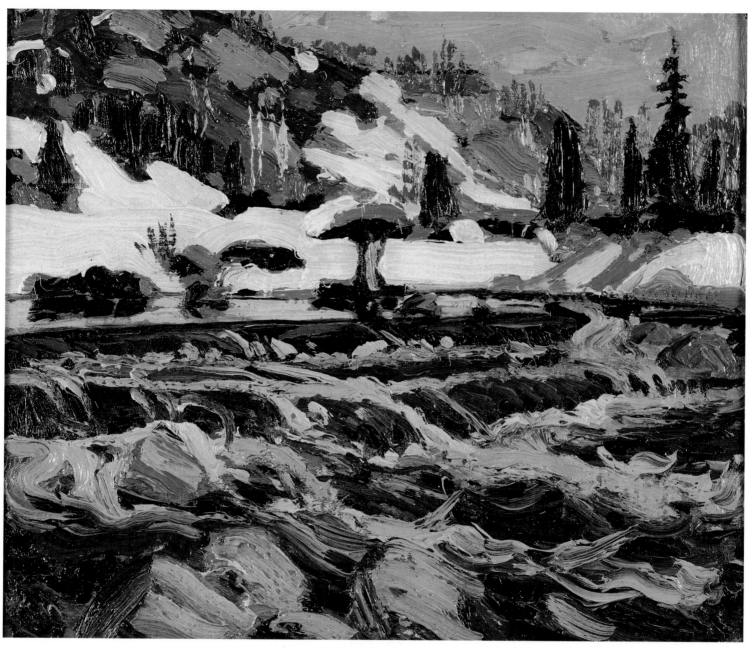

Plate 17. *The Rapids*
Oil on panel
21.6 x 26.7 cm

Ken Thomson, Toronto

On the back A.Y. Jackson, who owned the sketch, wrote in ink: "The Rapids, Probably in the spring of 1917." He told his niece, Dr. Naomi Jackson Groves, that he chose this work after Thomson's death because he could never paint a river the way Thomson did.

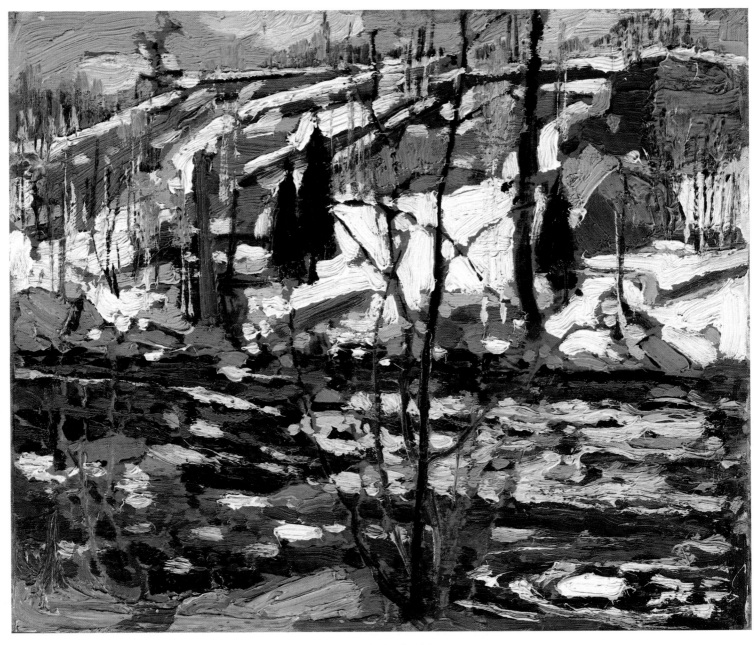

Plate 18. *Spring Breakup*
Oil on panel
21.4 x 26.7 cm
Private collection, Montreal

In the spring of 1919 MacCallum gave this sketch to Arthur Lismer. On the back MacCallum wrote,
"Painted in Algonquin Park Spring of 1917."

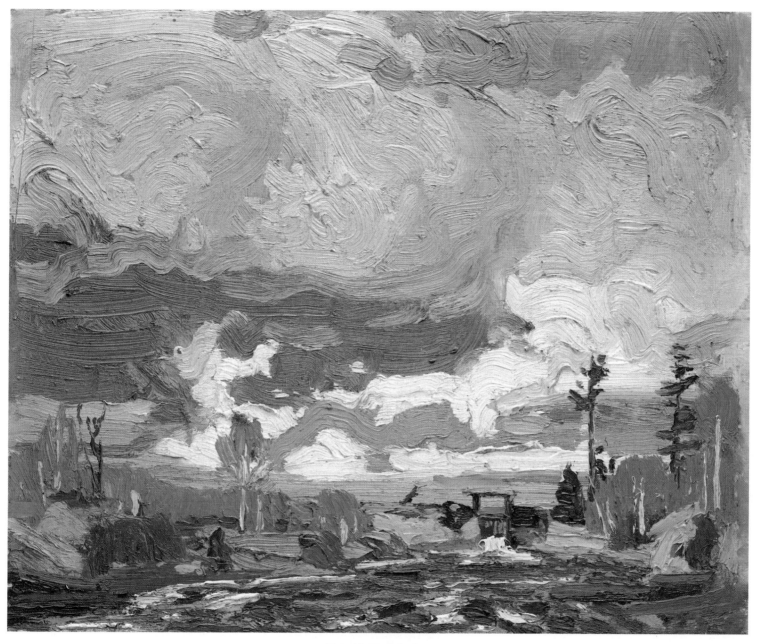

Plate 19. *Tea Lake Dam*
Oil on panel
21.3 x 26.2 cm
The McMichael Canadian Art Collection, Kleinburg
Purchased with funds donated by R.A. Laidlaw

On the verso of this sketch Thomson drew several sketches of a bird and MacCallum wrote a long pencil inscription: "Thundercloud in spring at chute where Muskoka River flows out of Lake looked at from the left side the rush of the water and the feeling of daylight is very marked as well as the feeling of spring – In the trees or bushes in foreground on right side of creek I found a poacher's bag with beaverskins & c. – sketched just before his drowning."

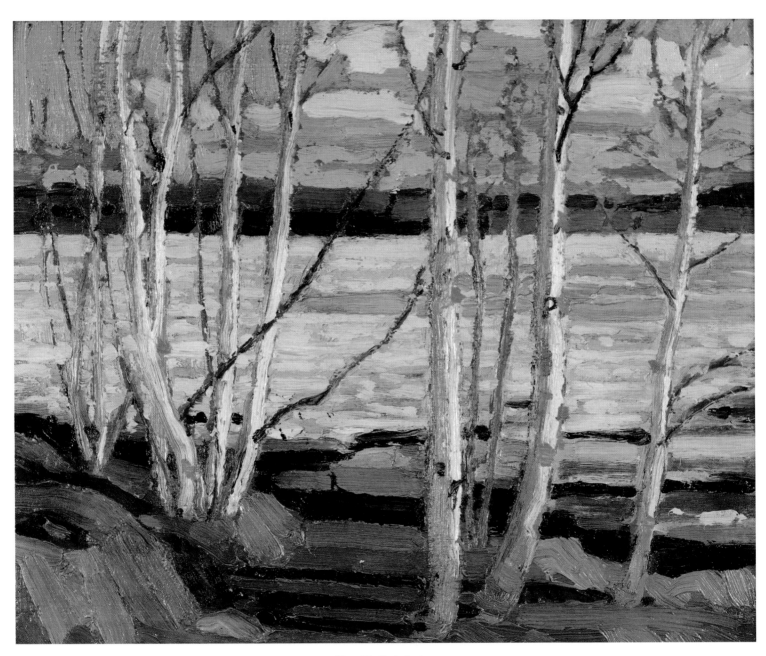

Plate 20. *Early Spring*
Oil on panel
21.6 x 27.3 cm
Ken Thomson, Toronto

Verso: (pen) "As a brother of Tom Thomson and knowing his work well I have no hesitation in confirming
that this sketch is his work, July 21, 1958 Geo Thomson"; (pencil) "Early Spring x 1 Tom Thomson"

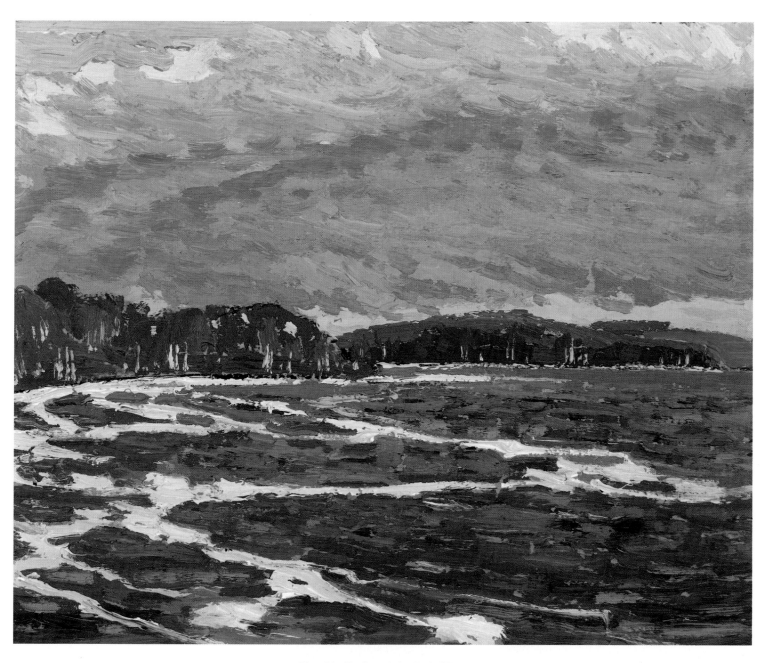

Plate 21. *Northern Lake, Early Winter*
Oil on panel
21.6 x 26.7 cm
Private collection, Calgary

This sketch belonged to the family.

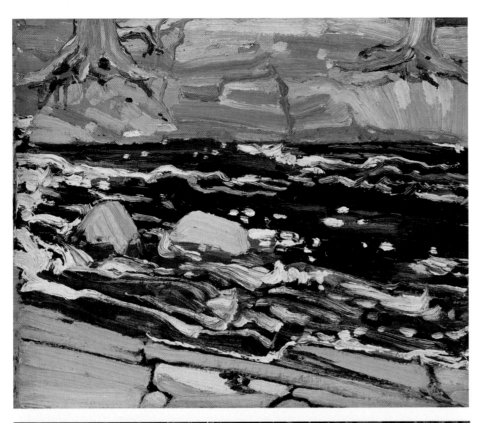

Plate 22. *Dark Waters*
Oil on panel
21.3 x 26.8 cm
National Gallery of Canada, Ottawa
Bequest of Dr. J.M. MacCallum, Toronto, 1944

MacCallum acquired this sketch from Thomson's estate in 1917, which helps support the date.

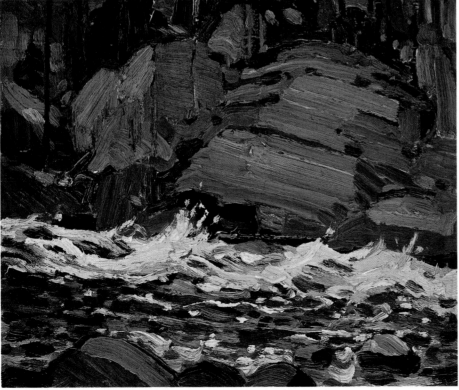

Plate 23. *Swift Water*
Oil on panel
21.3 x 26.8 cm
National Gallery of Canada, Ottawa
Bequest of Dr. J.M. MacCallum, Toronto, 1944

Verso: (label, partly torn) "Dr. James MacCallum / The Rapids – last year"

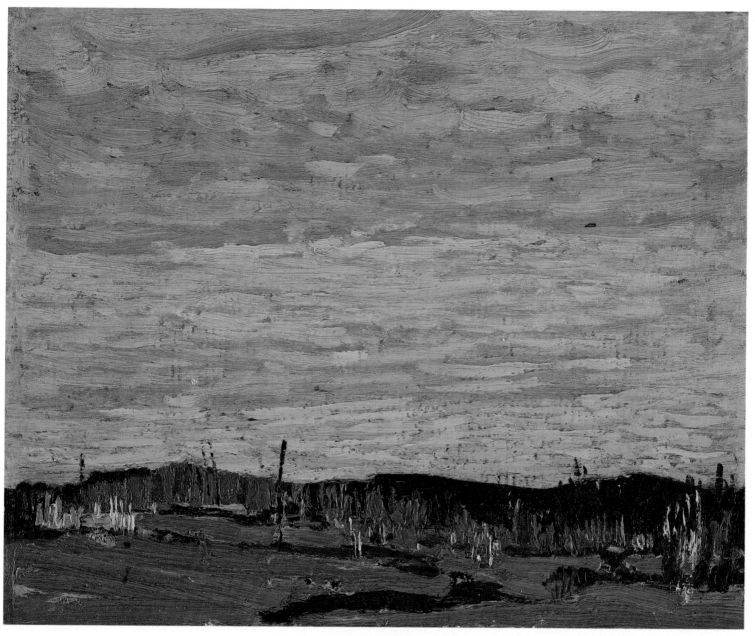

Plate 24. *Spring*
Oil on panel
21.6 x 26.7 cm
Art Gallery of Ontario, Toronto
Gift of the Reuben and Kate Leonard Canadian Fund, 1927

Verso: (pencil) "This sketch was painted / in the spring of Thomson's drowning / J. MacCallum."
This was one of the Thomson sketches Lawren Harris kept for himself. On the back he wrote his name.

"The weather has been fine and warm." – Thomson to MacCallum, 8 May 1917

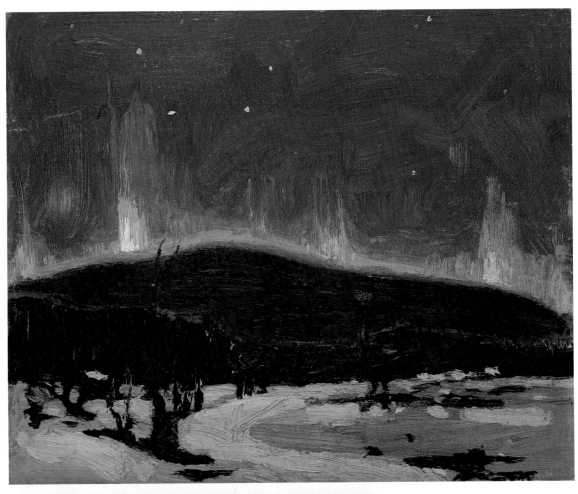

Plate 25. *Northern Lights*
Oil on beaverboard
21.6 x 26.7 cm
National Gallery of Canada, Ottawa
Bequest of Dr. J.M. MacCallum, Toronto,
1944

Thomson painted another sketch
in oils on the back.

"… have every intention of making some more …"
– Thomson to MacCallum,
7 July 1917

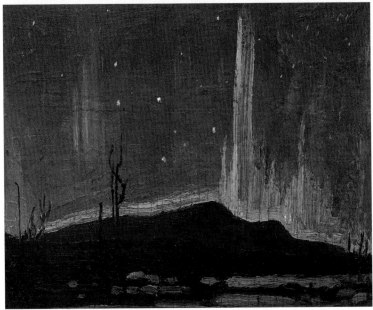

Plate 26. *Northern Lights*
Oil on panel
21.0 x 26.0 cm
Private collection, Ottawa

The Thomson family owned this sketch.

Note the cracking through the board of this sketch. It is a characteristic of Thomson's (and Jackson's) panels of 1914, and there are the indications of an earlier work under the paint. Perhaps this is one of the sketches Thomson scraped off and repainted.

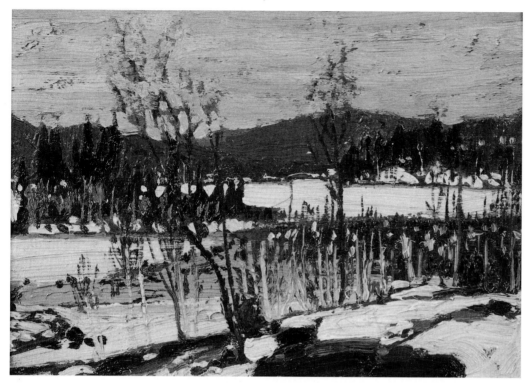

Plate 27. *Winter Thaw*
Oil on panel
11.8 x 17.2 cm
Private collection

This work, owned by Thomson's family, is one of the tiny panels he painted on wood from packing crates.

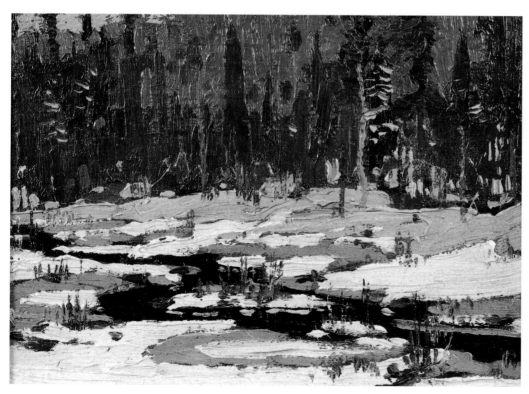

Plate 28. *Winter Scene*
Oil on panel
11.8 x 17.2 cm
Private collection, Calgary

Like Plate 27, this scene was painted on the tiny panels Thomson used in the last spring of his life.

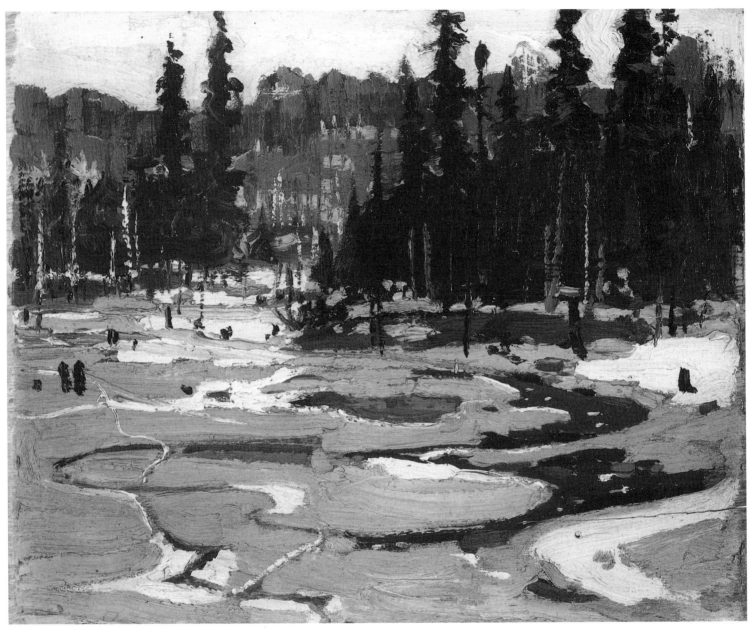

Plate 29. *Portage, Ragged Lake*
Oil on panel
21.5 x 26.8 cm
National Gallery of Canada, Ottawa
Bequest of Dr. J.M. MacCallum, Toronto, 1944

On a label on the verso of this sketch MacCallum wrote (but crossed out), "Spring" and "Portage Ragged Lake." The scene seems to fit with others of this season.

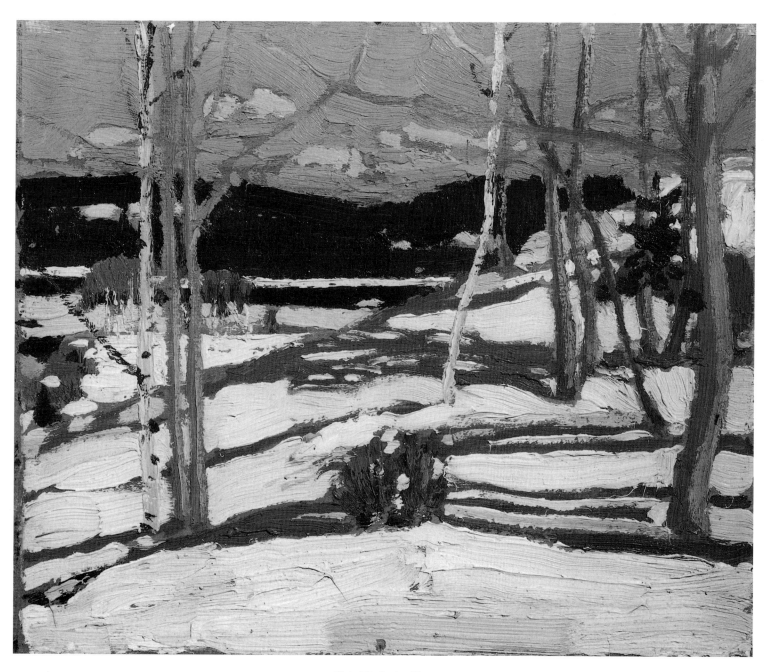

Plate 30. *Spring Thaw*
Oil on panel
21.25 x 26.25 cm
Private collection, Vancouver

This work belonged to the Hon. Vincent Massey, as did Plate 2.

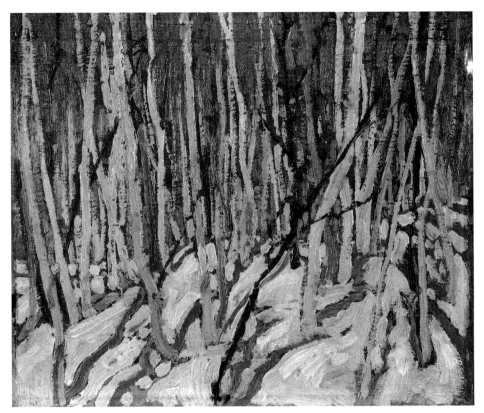

Plate 31. *Birch Trees in Snow*
Oil on panel
21.6 x 26.7 cm
Private collection, Sarnia

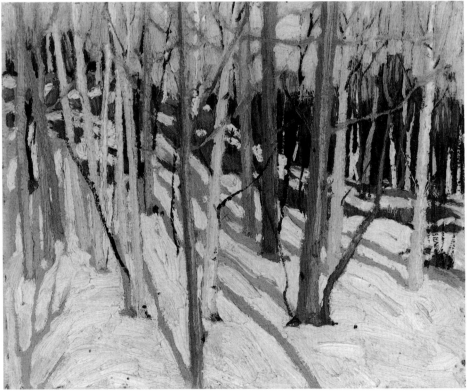

Plate 32. *Snow in the Woods* (II)
Oil on panel
21.4 x 26.6 cm
National Gallery of Canada, Ottawa
Purchase, 1918

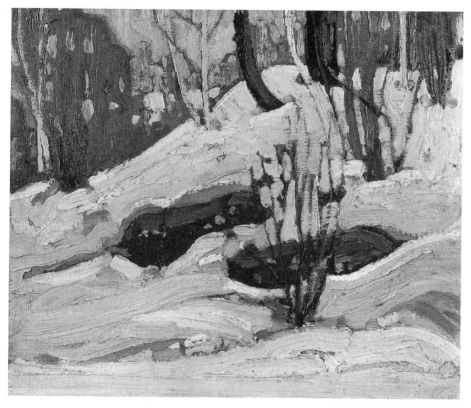

Plate 33. *Thaw: Snow Banks*
Oil on panel
21.5 x 26.8 cm
National Gallery of Canada, Ottawa
Bequest of Dr. J.M. MacCallum, Toronto, 1944

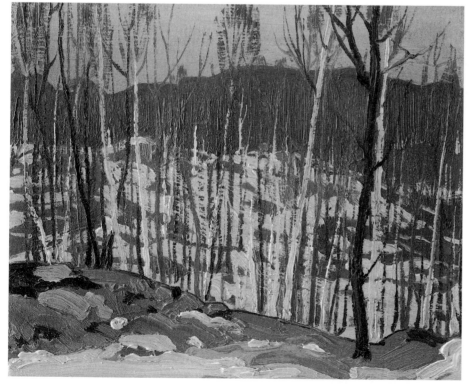

Plate 34. *Early April*
Oil on panel
21.1 x 26.7 cm
National Gallery of Canada, Ottawa
Bequest of Dr. J.M. MacCallum, Toronto, 1944

Dr. MacCallum wrote on the label on the back, "Early April."

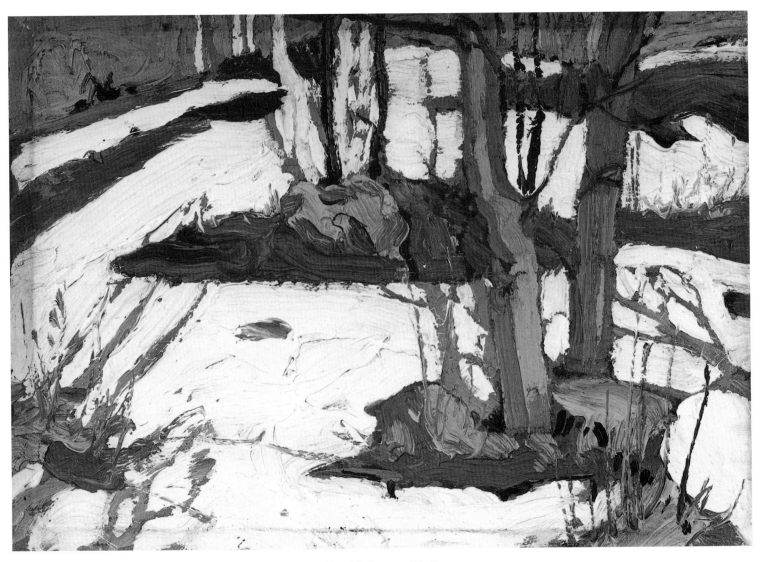

Plate 35. *Snow and Earth*
Oil on panel
12.5 x 18.12 cm
Private collection, Toronto

This is another of the small panels painted by Thomson this spring.

"The weather has been wet and cold all Spring ..."
– Thomson to MacCallum 7 July 1917

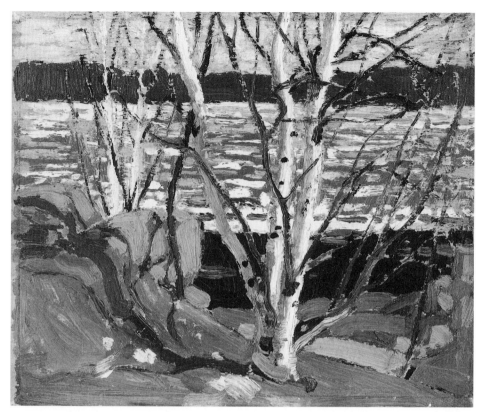

Plate 36. *Melting Ice*
Oil on panel
21.6 x 26.7 cm
Private collection

Verso: (pencil) "Wm. Henry"; (pencil) "No. 147 Mrs. Harkness / Melting Ice"; (on brown paper) "probably about 1915–16" "GT"

The work has no studio stamp and seems closely related to Plate 20 so I have dated it to Thomson's last spring, although George Thomson dated it earlier, as we can see from his note.

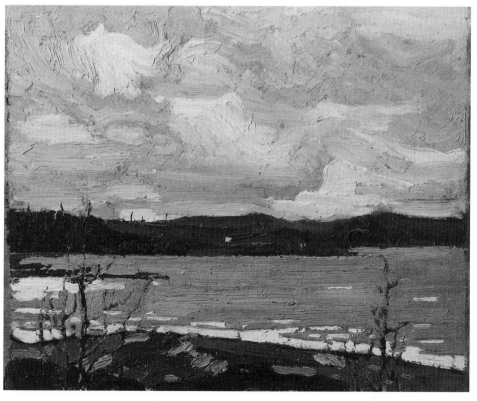

Plate 37. *Cold Spring*
Oil on panel
21.6 x 26.7 cm
Private collection

Verso: (pen incription) "Sketch by Tom Thomson / –1917–"

This sketch belonged to the Thomson family.

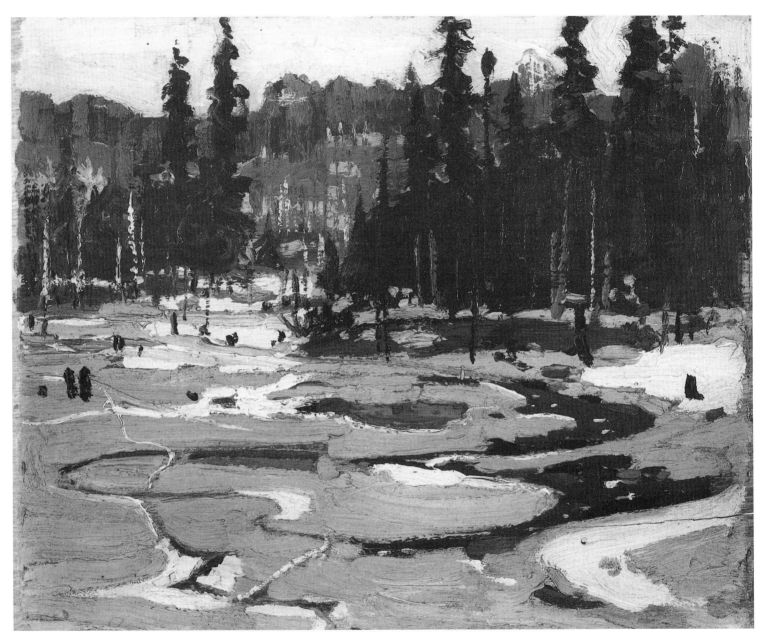

Plate 38. *Spring in Algonquin Park*
Oil on board
21.6 x 26.7 cm

The McMichael Canadian Art Collection, Kleinburg, Ontario

Verso: Toronto/January 28 — 1928 / "This is one of Tom's pictures / which was given to me by Father / today at Owen Sound. It was one / of the pictures taken by Father from / Mowat Lodge, Algonquin Park, in 1917 / when Thomson died, and it was painted in / the spring of 1917. I asked Dr. MacCallum of / Toronto over the telephone today whether it would / be possible to have Tom's seal affixed to this sketch / He suggested writing the above to establish its authenticity G.W. Thomson"

CHAPTER THREE
The Toronto Years

With its population of 226,000, the Toronto Thomson came to in 1905 was much larger than Seattle. Most of its immigrants were from Britain, and in comparison with the American city it was older, more conservative, and much stuffier. Yet in comparison with Owen Sound it was rich: it offered museums, art galleries, theatres, concert halls, and art schools. In 1903 the Annual Report of the Toronto Board of Trade reported that the city

> is widely known as the artistic, literary and musical centre of the Dominion and its influence in the direction of refinement and culture has impressed itself strongly upon the people of Canada. The list of its institutions for the civilization of the nobler arts is a long one, while in the beautifying of its avenues, the adornment of its homes and the decoration even of many of its industrial establishments it presents a model to other centres of population. Two fine museums contain hundreds of valuable specimens and documents ... Music is represented by three excellent conservatories, to which students come from all over Canada and many foreign countries.[1]

A.Y. Jackson put the matter succinctly: it was a stimulating city in which to pursue the arts. It was also the centre of the publishing business, and provided a market for artists who could do illustration and design.[2]

The work Thomson did in Toronto was a step forward in design toward the curvilinear fashion which showed the influence of Art Nouveau. Thomson's water-colour sketch for a stained-glass window, apparently intended for Havergal College, shows a student gracefully bowing as she holds her diploma (Fig. 36). The background frame suggests an Art Nouveau mirror with an organic motif.

Thomson began his career as a painter in 1906 by copying the work of others. Even later, in the years of his maturity, he liked to rework motifs from magazines and the paintings of fellow artists. The kind of pen work that was his specialty seems also to have influenced the way he held a brush; his strokes have an energetic, linear quality. Often a calligraphic element appears in the foreground of a painting.

Working as a commercial artist brought Thomson at least to the suburbs of art. In his spare time he sketched — in Seattle, the beauties of Puget Sound (Fig. 37); in Toronto, High Park, Lambton Mills near the Humber River, or nearby Lake Scugog, not far from Claremont, where his father had grown up. Perhaps because of the influence of his brother George, who moved from Seattle to study at the Art Students' League in New York in 1906, Thomson took lessons in Toronto at night school in 1906, probably from William Cruikshank. At that time, Cruikshank, who taught Drawing from the Antique at the Central School of Art and Design, urged Canadians to paint their own environment.[3]

Thomson grew up in farm country. It seems appropriate that his first works, from around 1901, should have Christmas card–like subjects — pine trees, fencelines, streams, and country houses. They evoke the adjective "picturesque." Only later, in 1912, when he learned a

technique to assimilate what he saw, did he develop an ability to create images with permanent value. During the decade from 1901 to 1912, the young man of twenty-four grew into a thirty-five-year-old artist who had learned to convey in paint his awe before and reverence for nature, and his feeling that it was sacred. What transformed him?

In those years he came under the influence of masters in the engraving trade, most of whom he met at Grip Limited, where he went to work in 1908. Grip was named for the cynical raven in Dickens's novel *Barnaby Rudge*, the same raven used in the flag and name of *Grip Weekly*, a newspaper of political comment established in 1873 by the Canadian cartoonist John W. Bengough. To make engravings for this paper, the company established a small engraving department, which rapidly grew to serve other newspapers and commercial houses. Though *Grip Weekly* discontinued publication in 1884, its art and engraving department continued to flourish.

When Thomson joined Grip, the growing and prospering railway generated much of the commercial art and engraving in Canada: posters, brochures, and other advertising for immigration, western settlement, hotels, and resorts.[4] Much of this business was placed with agencies and commercial artists in New York, and Grip aimed to break into the market by offering art work of a competi-

Figure 36
Design for Stained Glass Window, Havergal College (?), c. 1905–07
Watercolour on paper
32.5 x 15.7 cm
Art Gallery of Ontario, Toronto

Figure 37
View of Puget Sound, Roche Harbor, c. 1905
Photograph courtesy of the Seattle Historical Society, Museum of History & Industry, Seattle

tive quality. It engaged an art director, A.H. Robson, and a painter, J.E.H. MacDonald, who was considered "the anchor" of the design team. Robson hired the thirty-one-year-old Tom Thomson and placed him under MacDonald. In the years that followed, Thomson often completed work begun by MacDonald, or worked under his direction. Thomson's work was often of a modest cast: his specialties were lettering and, in executing designs created by the senior artists of the firm, he handled the Ben Day machine. Named after inventor Benjamin Day (1838–1916), a New York printer, this mechanical device introduced tones of grey into photo-engraving by means of dots or stipples. (The dotted areas give an effect of shading.) Thomson also did advertising design work, catalogue and magazine covers and pages. By contrast, Arthur Lismer, who came in 1911, was a figure man, having had the advantages of English art-school training.

One of the lesser artists who worked at Grip recalled later that it had a good air, its atmosphere not too rigid or confining. "A fine spirit pervaded the Art Room, and through all the fun and pranks we managed to turn out a high standard of work." "At one end of the room sat Jimmy MacDonald ... His desk was covered with sketches, note books, paints and brushes, all in utter confusion. It was said that when he left the Grip he found on his desk material which had been missing for years."[5] Among the other artists, at different times, were Fred Varley, Franklin Carmichael, and Frank (later Franz) Johnston. They, along with MacDonald and Lismer, were founding members of the Group of Seven in 1920.

It would be too much to say that the spirit of the Group was already present when Thomson went to Grip, but something was in the air. Thomson's work and friendships at Grip Limited (and in other engraving houses like Rous & Mann, to which the same group of artists moved in 1912) encouraged him as an artist. A spirit of excitement, vitality, and a sense of a new age dawning pervaded the atmosphere of these offices.

By the fall of 1911 Thomson began to think about painting seriously. In 1912 he bought his first painting outfit and made several small sketches. But even with the encouragement of MacDonald, nothing interesting in his

work might have emerged if Thomson had not, in the summer of 1912, made a trip to Northern Ontario with one of his friends from Grip, the English artist William Smithson Broadhead. The combination of an adventure in nature and in art brought out a new quality in his work. "We started in at Bisco [near Sudbury] and took a long trip on the lakes around there up the Spanish River and over into the Mississauga water," Thomson said to a newspaper reporter later, sounding a little like a tourist. "The Mississauga is considered the finest canoe trip in the world."[6]

The images poured out of him, swift, sure, immediate; his sketches from the trip are dark and strong (Fig. 38). Quickly, he compiled a body of work admired by his peers. A friend found that they "caught the real northern character" and showed an "intimate feeling of the country."[7] A.Y. Jackson later spoke of what the circle of friends meant by the "North" – it was the land as it "appeared to the lumberjack, or the prospector – a rough unsettled country. You travelled by canoe, went over long portages, ran rapids."[8] For this group the "North" meant an area of unspecified extension which had to be approached in a special way, through the hard work of camping and exploring. It seems not to have had anything to do with

Figure 38
Mississauga, 1912
17.5 x 12.5 cm
Oil on panel
Private collection, England

Indians, though somewhere in the back of his mind Thomson must have thought of them. In an early sketchbook, he had drawn a moccasin and a tomahawk (Fig. 39). And, with his lank black hair, worn long, he was said to look like an Indian.

The countryside of Thomson's own home in Georgian Bay looks to our eyes like quintessential Group of Seven country, but Thomson had never found it a congenial subject. The North was special, different, farther

Figure 39
Sketchbook page, c. 1908
Art Gallery of Peel
Gift of Robert and Betty Bull, 1993

away; it involved a journey of discovery. In 1912 the boundary of Ontario was extended to its present limits. Public awareness of the North would have been heightened by reports of this extension.

The relative remoteness of the North was important: it fulfilled the romantic artist's longing for the exotic, but it had a special Canadian feeling. Harris had already written with compelling passion about what the North could mean. In a review of an exhibition by Arthur Hemming, published in *The Lamps* in 1911, he said that the paintings must have required years of study in the North: "… the cold crispness of its snows, the suggestion of mystery and bigness … is done in a perfectly simple and masterly way."[9] Thomson could have known of his beliefs, perhaps through MacDonald, who had met Harris in 1911. He would have wanted his friends to like his work – and certainly they reacted with fervour. The 1912 sketches, along with those done in Algonquin Park the following year – mostly ragged and rather severe distant shorelines – are recognized as the first awakenings of the Group of Seven, both philosophically, because of the way the imagery was obtained, and in subject matter (Fig. 40).[10] At this moment Thomson was only four years away from the high point of his career as a painter.

For Thomson, living in the wilderness led to a new perception. The way he first approached the North – through the use of the camera – reinforces the idea. The way he used the camera, for "still shooting" (photographing rather than shooting wild animals), was typical of the naturalist. He and his friend William Broadhead, who accompanied him on the Mississauga trip, took many snapshots of game, mostly moose, but their canoe was overturned in the river and they lost most of their film: "We only saved two rolls … out of about fourteen dozen," reported Thomson.[11] Some of the photographs he took later in Algonquin Park have an archival interest, whether they record beaver and beaver dams, a ruffed grouse against the sky, a loon's egg, or a squirrel.[12] The camera may have helped him recognize what the North meant as a source of fresh subject matter; he may also have intended some of these photographs to serve as rough sketches for paintings. Art textbooks of the time gave advice on

how to do this, postulating that in sketching from a photograph of a landscape one must stress the "main interests."[13]

Thomson quickly realized that untamed places like this were the raw material of the new Canada. "The North Country at that time meant Algonquin Park," said Jackson.[14] For Thomson it was paradise. Many have noticed the shrine-like, mysterious quality of some of his paintings, such as *Northern River* (1914–15): the well-lit central space, the contrasting darkness of the silhouetted shafts through which it is viewed, and the quiet mood these forms impose – together they suggest a church interior. Like many others, Thomson found in the park "recreation and restoration in a closer approach to nature than can be found in a busy street or crowded mart," as an early travel article noted.[15] The land was his refuge. He also loved its vast, theatrical atmospheric effects: clouds, storms, lightning, sunrise or sunset (Figs. 41–43); and this solitary, aromatic wilderness, with its cool depths, could easily be reached by rail. In Algonquin Park Thomson could live the "simple life" he preferred, and devote him-

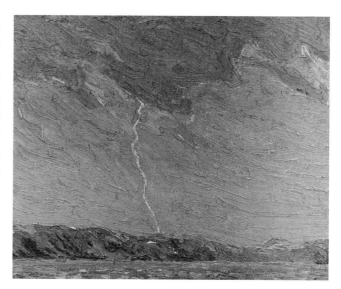

Figure 41
Lightning, Canoe Lake, 1915
Oil on wooden panel
21.6 x 26.7 cm
National Gallery of Canada, Ottawa
Bequest of Dr. J.M. MacCallum, 1944

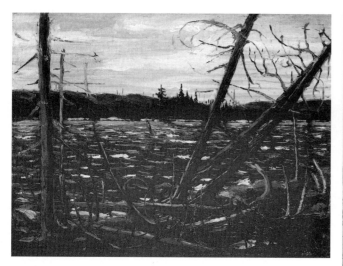

Figure 40
Northern Lake, c. 1912
Oil on linen laid down on board
17.5 x 25.25 cm
Private collection, Toronto
(Thomson used this sketch for the canvas *A Northern Lake*, 1913, in the collection of the Art Gallery of Ontario, Toronto.)

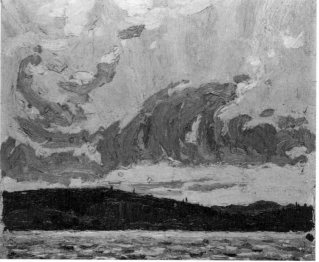

Figure 42
Morning, 1915
Oil on board
21.6 x 26.7 cm
Tom Thomson Memorial Art Gallery, Owen Sound
D.I. McLeod Bequest, 1967

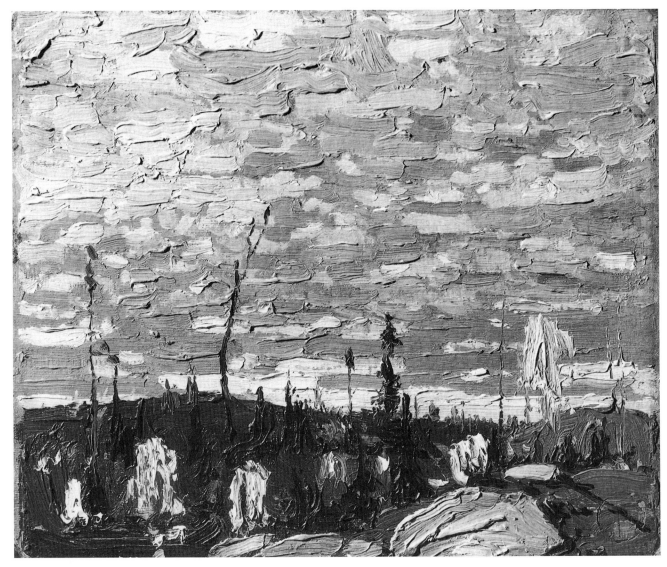

Figure 43
Sunrise, 1915
Oil on board
21.6 x 26.7 cm
The McMichael Canadian Art Collection, Kleinburg
Gift of the founders, Robert and Signe McMichael, 1972

self to his favourite sport, fishing (Fig. 44). Furthermore, his love and increasing knowledge of the natural world were making him a better painter. He had been at first awkward and unconvincing, but observation and being in the North improved his work.

Invigorated by his successes of the previous summer, he went north again in May 1913, first to the Metagami Reserve south of Timmins, probably to try the fishing, then back to Algonquin Park where the catch was better.[16] Now that he knew what he wanted, the pattern of

his life changed. He "lived through the winter in town with the sole idea of making enough money so he could go north as soon as the ice broke in the rivers and lakes," Lawren Harris said.[17] In time, having given up his job as an engraver, he worked in Algonquin Park, first as a guide and then as a fire ranger and park warden, though always with the idea that he could go back to his old job if necessary. Being a guide helped him see the park. Just as he had talked to his friends, the artists, he now talked to tourists, asking them what they found striking or beautiful – perhaps a sunrise or sunset. Ottelyn Addison, the daughter of Mark Robinson, who has written several books on Thomson and Algonquin Park, delicately suggests that for tourists with no artistic leanings, Tom was not in the "first choice circle" of guides, even though he had an "uncanny ability to catch fish and his reputation as an expert campfire cook soon became well known."[18] His art peers, however, believed in his abilities as a guide as they did in all his talents. Thomson, they felt, seemed to think of the park as almost his personal property. As Jackson said, Thomson "was the guide, the interpreter, and we the guests partaking of his hospitality so generously given."[19]

Thomson's letters to his friends often contained invitations to join him. Almost all of his Grip associates and other close painting friends, such as Lawren Harris, Jackson, Fred Varley, and Arthur Lismer, did follow him to the park, sometimes in a group (Fig. 45). Lismer came in late April or early May of 1914 and was in rapture over the park's beauty, especially its wild animals, the deer and wolf, porcupine and moose. He later wrote movingly about the "wonderful miracle of a northern spring."[20] In the fall of that year Lismer returned, this time with Varley and Jackson. In 1915, Lismer and Varley again came to visit; Harris came in April 1916. There were other visitors, particularly Dr. MacCallum.

The impact of these visits on Thomson can be gauged by the improvement of his work and the volume of his output. The painters in his circle had always helped him, perhaps even touching up parts of his early canvases, as J.W. Beatty and Varley are rumoured to have done.[21] Other talented painters, like Carmichael, may have offered advice.

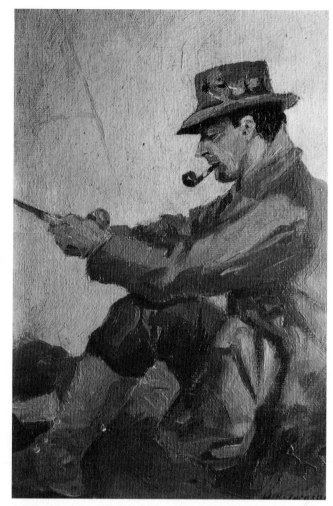

Figure 44
H.B. Jackson (1871–1952)
Tom Thomson, Rainy Day in Camp, 1912
Oil on board
25.3 x 17.5 cm
National Gallery of Canada, Ottawa

The three crucial figures in his development as a painter were, in chronological order, J.E.H. MacDonald, A.Y. Jackson, and Lawren Harris. Thomson's sense of design was undoubtedly nurtured by his friend and mentor MacDonald, who had an elegant sense of picture-making that Thomson admired. "He learned a lot from MacDonald," Jackson said.[22] What he learned can be observed in the similarities between MacDonald's early

Figure 45

Algonquin Park, October 1914. From left to right: Tom Thomson, F.H. Varley, A.Y. Jackson, Arthur Lismer, Marjorie Lismer, and Mrs. Lismer

Photograph courtesy of the Art Gallery of Ontario, Toronto

work and some paintings by Thomson; in 1914, for example, Thomson undertook a tapestry of cool blue and green shadows on the snow, which recalled a subject painted in 1912 by MacDonald. The echoes are never slavish imitations, but simply memory notes. Probably it was MacDonald, too, who suggested that Thomson put his design abilities to use in simplifying, eliminating inessential detail, and reorganizing the scene before him. Jackson's influence is evident in Thomson's method of applying paint: a modified form of Impressionism. Jackson always said he was responsible for the way Thomson began to combine colours using separate strokes or clean-cut dots.[23] It is likely that Thomson also borrowed books from the library on the subject.[24] Harris's influence on Thomson – a stress on three-dimensional form and the use of large blocks of colour – begins to be evident around 1916. Harris had been especially kind to him from 1913 onward, and often helped him with business advice. He had given Thomson fresh canvas and a place to live at a nominal rent in Toronto in the Studio Building, which he

helped to build with MacCallum in 1913; he then fixed up the shack beside the building when Thomson found the studio he shared with Jackson too expensive. Sometimes, with MacCallum, he even acted as Thomson's banker. Thomson, in turn, inspired his circle of friends through the colour and vigour of his work, and his infectious enthusiasm for the wilderness. "We continuously derived inspiration and encouragement from each other," Harris said.[25]

The story is one of eager young artists, of commitment and promise. We know that the Group of Seven will be founded in 1920, three years after Thomson's death. There is little room in Harris's narrative to mention Thomson's depressions. Harris and others recalled the way he flicked matchsticks at wet canvas, moodily staring at a painting in disgust. He had fits of unreasonable despondency, wrote Fred Housser, quoting from Harris: his most difficult stumbling-block was a disbelief in himself. He was erratic and extremely sensitive.[26] Some recalled that he came home drunk to the Studio Building more than once. He had picked up the habit when he was young, and seems to have concentrated his attention on drinking as he did on other matters he liked. As an old friend said, "there was absolutely no sense to the manner in which Tom set about his drinking when the humour seemed to take him."[27] The dark side of Thomson's anger and self-hatred expressed itself later in Algonquin Park, and may even have had a part in his death.

That Thomson occasionally drank too much has no bearing on his art, but his anger does. His friend, park warden Mark Robinson, recalled that at times Thomson appeared quite "melancholy and defeated in manner." Then he would suddenly "awaken," and would be "almost angry in appearance and action. It was at these times he did his best work."[28] His anger sharpened the way he painted, helping him dare to work more roughly and in a more abbreviated manner. Besides making him resolute, it readied him to paint. According to Robinson, after a period of anger Thomson "would quite often come dashing into my cabin and in an excited tone ask about certain Rocks or trees or rolling Hills [sic]."[29] Once he had established the location of what he wanted to paint, he set off to carry out his plan.

Anger may also have made him paint more assertively. "Damn them!— I'll show them—," he said to Dr. MacCallum, who recalled as an example of "showing them" the big blotches of pure colour Thomson used to create The Pointers.[30] By "them" Thomson meant not only his critics, "who," as MacCallum noted, "had been attacking him and his methods," but also his larger critic, the general public.[31] Yet, looking back at his exhibition history and at the mention of his work in The Globe, among other newspapers, magazines, and books, we may be surprised to find his reviews filled with praise. Perhaps what we have here is more evidence of Thomson's acutely sensitive nature; or perhaps MacCallum had expressed some slight skepticism over his colour. Whatever the reason, Thomson was often angry, as well as desperately anxious to achieve, which may help us to understand the speed with which he developed. By 1914 he was painting well, though with a thick pigment and a sometimes messily handled, crusty impasto. In 1915, and sometimes in 1916, he achieved the jewelled surface of Impressionism, and occasionally moved beyond its atmospheric effect to the crisp outlines of Post-Impressionism. At the same time, particularly in the canvases, the Art Nouveau style of his commercial art background kept reappearing, a persistent and powerful habit of composition.

Provincialism can have a raw energy that uncovers new possibilities in older art and transcends safe stereotypes. Part of Thomson's strength as a painter was his lack of knowledge of what the schools taught. When A.Y. Jackson told him about colour, or Harris lent him art books, he seized upon the knowledge voraciously. He took unexpected and inspired risks – with brilliant results. Working to achieve his own purposes, he recreated art from the ground up, and this is part of the excitement of his work.

Experts disagree over where certain works were painted. In 1953 and 1955 T.W. Dwight, a professor of forestry at the University of Toronto, wrote Martin Baldwin, director of what was then the Art Gallery of Toronto, about the location of The Jack Pine and The West Wind. Both were painted at Achray on Grand Lake in Algonquin Park, Dwight said; he sent a photograph of the red pine he

believed was the model.[32] This tree may also have been the model for another work by Thomson, although the resemblance could be a coincidence (Figs. 46–47). If the tree in the photo is the subject he painted, this is one of the few real chances we have to compare a work by Thomson with its subject and to confirm that his version, while it seems to condense more of the shoreline into his sketch, is accurate in its rendering of the foliage and the structure of the tree. Although broadly schematized, his painting has much more vitality and life than the photograph. As Dwight wrote, "What he paints is by no means an accurate portrait … but I think there is little question that he got all that he needed from the tree [for the *West Wind*]."[33]

Thomson himself stressed the way his paintings truthfully record the scenery, seasons, and times of day in Algonquin Park. "Pine Country," he wrote on the back of one sketch; "Spring," "November," and "Morning" on others. "When I take these sketches down to Toronto, the experts will all scoff at them, but those were the colours I saw," he said to a friend in 1913.[34] His words echo Dick Heldar, in Kipling's *The Light That Failed*. Heldar used "opal and umber and amber and claret and brick-red and sulphur – cockatoo-crest sulphur – against brown" and a "pure pale turquoise sky" to give "people the thing as God gave it."[35] Doubtless, too, Thomson was influenced by the colour used by painter friends such as Jackson and Harris. However, while he tried to be true to what he observed, he would have been the first to say his work wasn't "real" enough. "A photo would be great for people in Toronto but the painted things are awful [*sic*]," he joked to MacCallum.[36] That is, a photograph would have given a more perfect illusion of reality, clarity, perspective, and precision of detail than his painting. But Thomson would have known in his heart that literal real-

Figure 46
Red pine at Achray, Grand River, 1955
Photograph taken by T.W. Dwight. Courtesy of the Art Gallery of Ontario Archives

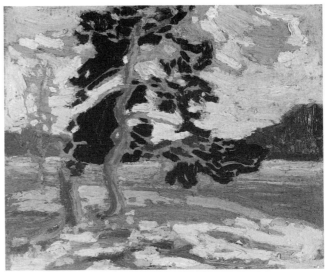

Figure 47
Pine Tree, 1916
Oil on panel
21.6 x 26.7 cm
Art Gallery of Ontario, Toronto
Gift of the Reuben and Kate Leonard Canadian Fund, 1927

ism was only one goal: something more was required, hence his way of exaggerating natural "facts" to make scenes more striking. Although his works seem vivid and unaffected, he meant to be daring, though within reason. "Lift it up, bring it out," he said to describe the way he used imagery.[37]

An incident recounted by Mark Robinson helps to put Thomson's way of discovering and using imagery in perspective. His manner could be on the wild side: obviously, he dramatized "the search":

> We saw Tom come almost at a run over the Joe Lake Portage. Canoe over his head. Throwing his canoe into the water he seized his paddle and shooting the canoe out into the water paddled like a mad man to our wharf, here he pulled up his canoe in haste and up into our cabin. Say Mark you know. I know you know just what I want, three trees. Spruce trees. Black spruce rough cold looking trees you know what I mean. Trees against a cold green grey northern sky where can I get them at once. I said Tom just tell me what you want and possibly I can help you. He then described the three Black Spruce trees, I said go to the little wharf below Sims Pit. You will find those trees you want in a group, but can I get them again[st] a cold northern sky I assured him that I thought he could. He was away like a shot and like a wild man was disappearing over the portage. Three days later Tom came in to our cabin. There was a big smile on his face, as he said, say Mark those trees were just what I required for my canvas, and the sky just right. How do you always know what I want. I could only tell him Tom you describe the things so accurately its no trouble to remember the odd things we see every day.[38]

Robinson never saw the sketch of the spruce Thomson painted, but in preparing my *catalogue raisonné* I wondered if Robinson could have condensed two separate incidents into one account. He first knew Thomson in 1914, and the group of erratically shaped trees in the foreground of *Algonquin, October* (Fig. 48) could possibly be the trees below Sims Pit. Black spruce always grow in low-lying marshy areas, and this seems to be such a place. Thomson would have favoured sites with a clear structure and strong design potential. He knew from his experience as a commercial artist that design is necessary to produce a striking, memorable image.

One must always qualify the literalness of Thomson's vision. Perhaps the best way to realize how he straddled

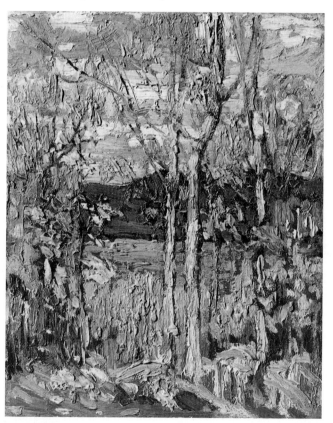

Figure 48
Algonquin, October, 1914
Oil on panel
26.9 x 21.6 cm
The McMichael Canadian Art Collection, Kleinburg
Gift of the founders, Robert and Signe McMichael, 1966

the fence between naturalism and abstraction is by looking at the seemingly "abstract" work Thomson painted. He seems to have done several of these sketches in the last autumn of his life, perhaps at a time when he felt discouraged about his work. He may have been angry, and thought of showing his critics what he thought of them by moving towards what he knew from painters like Jackson to be a contentious, difficult area of art of the time. Invariably, he used the backs of works he had painted earlier, as though he had simply run out of material and grabbed up a sketch to make a quick note. *Autumn* (Fig. 49), for example, was once the back of *Rounded Hill and River* (Fig. 50). We can see in this sketch that Thomson has powerfully condensed information about trees and colour into swirls of form – albeit forms related to the real world. His is an "impression," but as Robinson said, it is "accurate"; he has painted a précis of a scene, as many abstract artists would do later. There is a hardness to the form, with no soft edges or equivocation, and it combines the brilliant colour of a cherished place with profound seriousness, as though the sketch were an icon.

He did love Algonquin Park, and much of it was dramatic enough to paint just as it was – Lismer spoke of the "glamour" of the North, especially in the fall.[39] The land that Thomson knew was not pristine but ragged, with many burned-over areas (Figs. 51–54). He liked to paint dead trees or the skeletal shapes left by fire. The second-growth forest – especially the wild cherry trees that grew up after fire and blossomed in the spring – gave the land an ebullient vitality, which Thomson also enjoyed painting (Figs. 55–56). Many of his burnt-land subjects date from 1915, when he spent time in the area of Kearney, near the park. He may have stayed at McCann's Halfway House, which lodged loggers on their

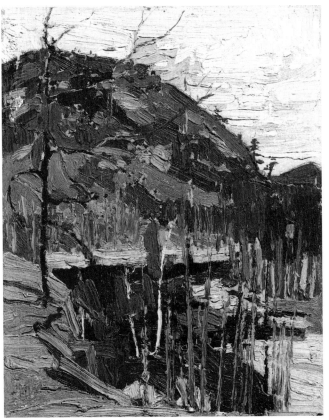

Figure 50
Rounded Hill and River, 1916
Oil on panel
26.7 x 21.4 cm
Art Gallery of Ontario
Bequest of Sir Frederick Grant Banting, 1941

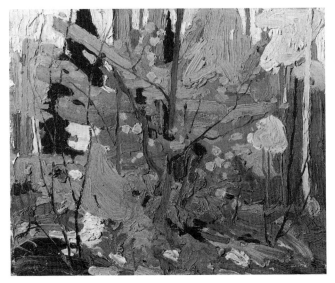

Figure 49
Autumn (verso of Fig. 50), 1916
Oil on panel
20.62 x 26.25 cm
Private collection, Calgary

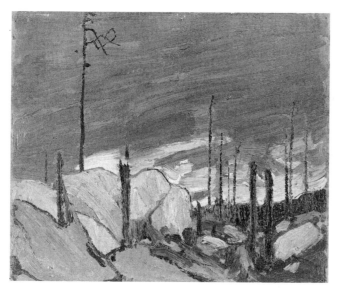

Figure 51
Burnt Country, 1915
Oil on panel
21.6 x 26.7 cm
Art Gallery of Ontario, Toronto
Gift of the Reuben and Kate Leonard Canadian Fund, 1927

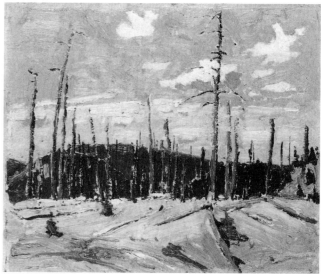

Figure 53
Burnt-Over Forest, 1916
Oil on panel
21.25 x 26.6 cm
Private collection, Toronto

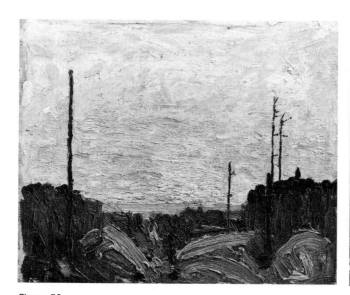

Figure 52
Burned Over Land, c. 1914
Oil on panel
21.0 x 26.7 cm
The McMichael Canadian Art Collection, Kleinburg
Gift of the founders, Robert and Signe McMichael, 1967

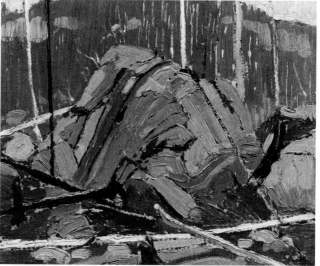

Figure 54
Rock – Burnt Country, 1916
Oil on panel
21.2 x 26.6 cm
Montreal Museum of Fine Arts
Gift of A. Sidney Dawes, 1947

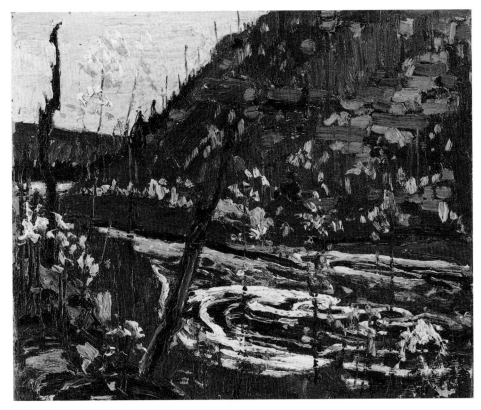

Figure 55
Wild Cherry Trees in Blossom, 1915
Oil on paper board
17.6 x 26.7 cm
Art Gallery of Ontario, Toronto
Gift of the Reuben and Kate Leonard Canadian
Fund, 1927

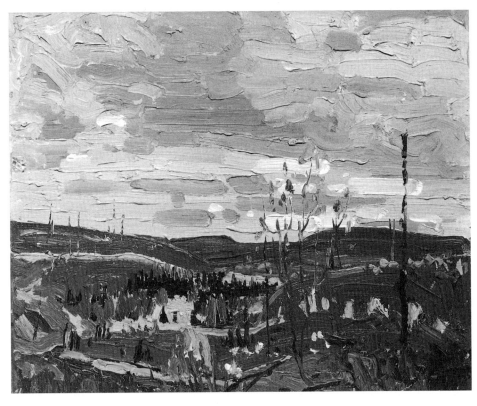

Figure 56
Wild Cherry Trees, 1915
Oil on panel
20.25 x 20.25 cm
Private collection, Ottawa

way to lumber camps. The area had been recently burned.[40] These stark subjects were mixed in his work with more dramatic scenes.

He was fascinated with anything that moved and flowed, day or night. Rapids, water bursting from a dam, or waterfalls were favourite subjects, as were flowers and animals (Figs. 57–59). He clearly loved the fall, not only for the brilliant reds of maples but for the yellows of the tamaracks (Figs. 60–61). One of the most spectacular places he painted was the Petawawa Gorges. In August 1916 he made a canoe trip down the south branch and sketched what are called the Capes, which stretch between high walls of rock. It was a moment in his work that called forth some strong, authentic images (Figs. 62–63).

What Thomson recorded was a place, a time of day, and, more distantly, his mood and feeling. He might paint

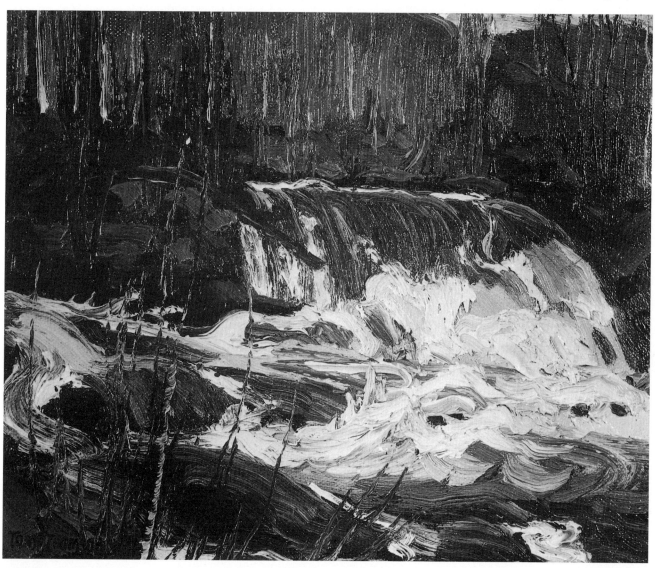

Figure 57
The Waterfall, Spring, 1915
21.6 x 26.7 cm

Private collection, England

a picture of his own tent (Fig. 64), then at night one of a deer that passed nearby (Fig. 59). But there can be no doubt that what we see in his work is a vital archival record: the artist's version of a place. Some of the sketches were saved by his friend Dr. MacCallum as being more significant. The doctor cared so much about Thomson's work that, as I have said, he dated the sketches in the Studio Building after Thomson's death, and on some of them wrote titles and notes. MacCallum's care and concern for accuracy are conspicuous. His bequest to the National Gallery of Canada in the 1940s included a special group of works he saved and donated because they provided an archival record of Algonquin Park. This group thus has a double value for us. The works in the National Gallery of Canada, along with those in the Art Gallery of Ontario and the McMichael Canadian Art Collection, are the works the public knows as most characteristic of Thomson, since they are so often on view in three major institutions.

The work Thomson painted during the last spring of his life, his day-by-day record of the changing weather of the park, looks like an unadorned report. The way he painted, however – his disciplined brush, his powerful though spontaneous technique, and the daring way he left areas of the sketch unfinished – make him something different from a "natural" or simple painter. He was an artist

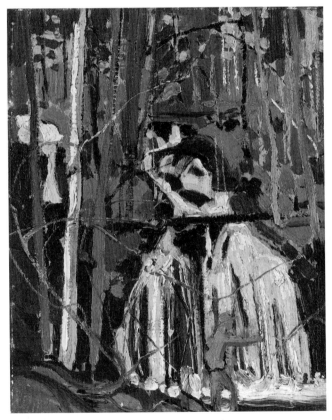

Figure 58
Little Cauchon Lake, 1916
Oil on wooden panel
26.6 x 21.4 cm
National Gallery of Canada, Ottawa
Bequest of Dr. J.M. MacCallum, Toronto, 1944

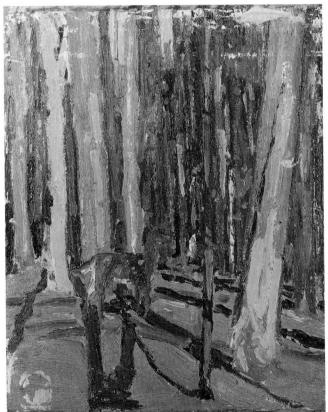

Figure 59
Deer (verso of *Artist's Camp, Canoe Lake*), 1916
Oil on panel
25.62 x 21.62 cm
Collection of Ken Thomson, Toronto

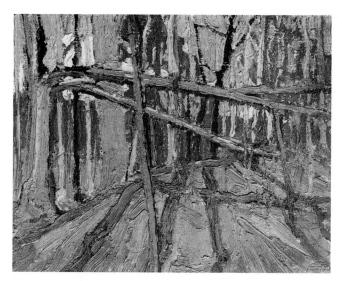

Figure 60
Forest, October, 1916
Oil on panel
21.0 x 26.7 cm
Art Gallery of Ontario, Toronto
Gift of the J.S. McLean Collection, 1970

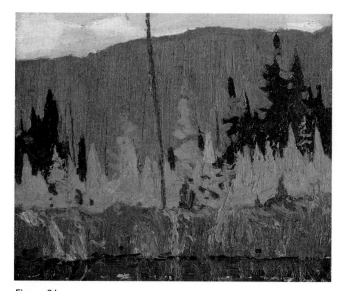

Figure 61
Autumn, Algonquin Park, 1915
Oil on panel
21.5 x 26.4 cm
Private collection, Toronto

of evident subtlety and artifice, not so much a poet as an exponent of the great tradition of *plein-air* painting that links Canadian artists to the British art of John Constable and before him to the precise realism of the seventeenth-century Dutch landscape painters.

Ann Bermingham, in analysing John Constable, argues that at the core of his nature painting there lies a dichotomy: "The impulse to record with naturalistic objectivity the scenes of his boyhood and an equally powerful desire to infuse these scenes with personal associative meaning."[41] Her discussion of the development of Constable's use of landscape from a private record of experience to a public, autobiographical art is revealing. Like Constable, Thomson was struggling to forge an equivalent for the emotions stirred by the scene before him. He may also have felt that there was a flaw in his way of making records. While living in the landscape, he managed to balance his desire to record as a naturalist with his wish to make art. He seems, however, to have found his expressive naturalism hard to reproduce when he was back in the studio. Part of his work lay in the search for the locus of a power he wanted to disperse and retrieve. There are later Canadian painters who were driven by the same feeling of needing to search before settling down to paint. Thomson's absolute belief in the necessity of representing what he saw, however, gives his work a gritty authenticity that is unusual, and helps account for why it has so much meaning. Every Thomson painting is worth absorbing; collectively they provide an education in seeing. Examining Thomson's work we may learn the value of pausing, slowing down to see and appreciate the power of the natural world. His work has a daring lack of ostentation, and the result is exhilarating.

Thomson's life story has been seen as embodying romantic truths, but it also contains certain bitter realities. The myth that developed after his death masks the personality of a difficult, complex man who was unhappy with his situation. He had received little recognition, though the art critic Hector Charlesworth had written in *Saturday Night* of the "real promise" of his work[42] and in March of 1914 he had been elected a member of the Ontario Society of Artists. His sales had been few, though

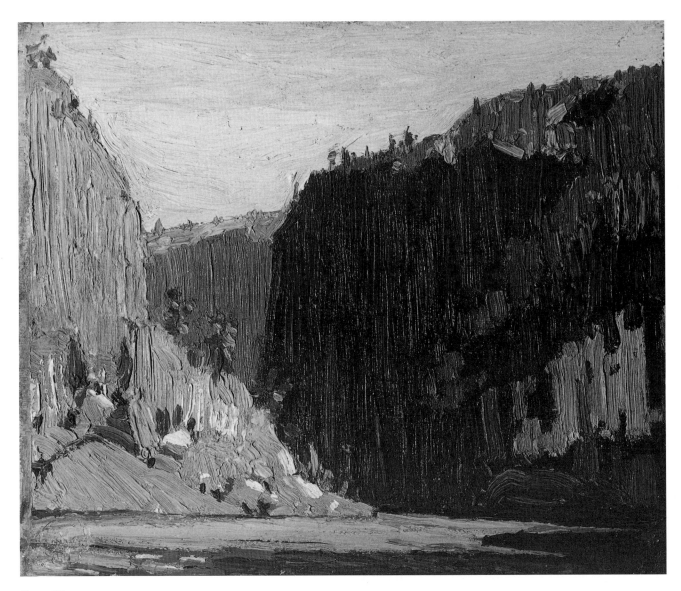

Figure 62
Petawawa Gorges
Oil on panel
20.62 x 25.62 cm

Private collection, Copper Cliff, Ontario

(This may be the Barren Canyon in Algonquin Park.)

the National Gallery of Canada had already purchased. His private life was unpromising. He had no home, no wife, poor prospects. In Algonquin Park he lived at a hotel which served as the post office, or in his tent. When he died at age thirty-nine, one of his family's letters lists the belongings sent back from Canoe Lake: plaid overcoat, caps, a worn-out suit, a pair of red Hudson Bay blankets, two brown canvas bags, one pair of drawers, four pair of socks, one aluminum three-quart pail, three lids, two plates, two tin cups, handkerchiefs, an ink bottle, two pipes. He also owned a pair of snowshoes and a new pair of shoes.[43] In the fight that is said to have ended his life he expressed anger over money he'd lent. Nor did there seem to be any immediate chance of his making much money, having given up his warden's job.

This apparently gentle person with the gallant manners, who loved his work and his family, was considered by people who lived in Algonquin Park to be an indolent, eccentric filler-of-time. As for his art, like many artists he hated his own paintings – at least for a while. "They call this art," he said to a friend, as he tossed a panel aside.

"Here's some of my junk," he said, when he showed his work.[44] To MacCallum he said, "I am only a bum artist anyway." His last letter – to his father – somewhat laconically explains that "I'll stick to painting as long as I can," as though his father knew he was not a person who stayed with anything for very long.[45] We don't know much of the candid Tom Thomson, only his strong, intense, spontaneous paintings. These works record the world he discovered, a place utterly different from his genteel home, where his craggy, difficult personality could not only fit but find magnificent fulfilment, becoming an essential part of the landscape's history, and of Canada's.

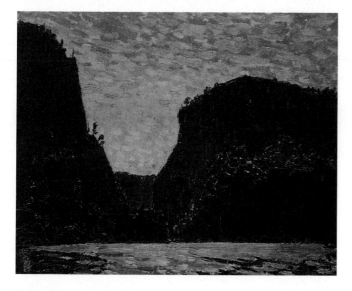

Figure 63
Petawawa Gorges, Night
Oil on wooden panel
21.1 x 26.7 cm
National Gallery of Canada, Ottawa
Vincent Massey Bequest, 1968

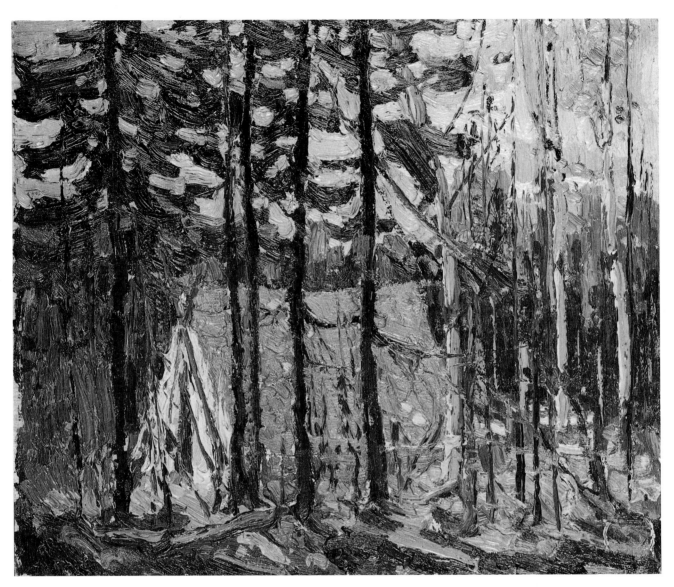

Figure 64
Artist's Camp, Canoe Lake, 1916
Oil on panel
21.62 x 25.62 cm
Ken Thomson, Toronto

CHAPTER FOUR
Echoes of Tom Thomson

Once upon a time a great Canadian painter died after living several lonely years in poverty. Those who knew his work saw in the painter a great talent, and found themselves inspired even by his choice of subject. His close friends, discerning the genius in his use of colour and the depth of his themes, volunteered to help his family sell the work crowding his old studio — work he had painted over four years. Thanks to the friends' efforts, everyone in time perceived the artist's real stature as a modernist giant, a brilliant interpreter of the Canadian landscape, and a symbolist whose work affirmed Canadian values.

This fairy tale is as flattering to the heroic rescuers of art as it is to the unrecognized prince, whom most people had taken for a good-for-nothing. All is simple here. The painter's greatness seems clear to the viewers' gaze as soon as they are told to look, and the friends' motives in helping seem equally clear: friendship should assist genius.

But if we fill in the names Tom Thomson, A.Y. Jackson, Lawren Harris, J.E.H. MacDonald, Arthur Lismer, Franklin Carmichael, and Dr. James MacCallum, the story becomes more startling. Most Canadians perceive Tom Thomson's greatness as an obvious fact of history: the magic of *The West Wind* seems beyond discussion. The idea that the Thomson myth had to be concocted seems alien.

Yet the process of creating his reputation was real enough, and the motive is clear. Members of the Group of Seven felt a sense of mission about Thomson because he was not only their discovery but, in an important sense, their invention. He had been MacDonald's assistant at Grip Limited, and was considered the bright young man of the company, to be helped and furthered in his career by his superiors. He was encouraged to go north to paint.

He did so, in Algonquin Park, coming back in November to paint in a Toronto studio, then going north again. He invited his friends to come, to visit and paint with him, which they sometimes did. His work was exciting. It inspired a new quality in their own work, whether of stronger, bolder colour or design. He represented youth, the future.

Then he died.

On 8 July 1917, he set off in his canoe to fish near Canoe Lake. His body was found over a week later. The coroner's report, now lost, returned a verdict of accidental drowning, though it noted a four-inch bruise on the right temple and an earbleed.[1]

Speculation that Thomson's death was not a simple accident has never stopped. How he died has become a staple of writers, amateur sleuths, and serious scholars. There are two books which deal with the subject: William T. Little's *The Tom Thomson Mystery* (1970) and a novel by Roy MacGregor, *Shorelines* (1980). Joyce Wieland's film, *The Far Shore* (1975), deals with the suspected murder of a Thomson-like hero. Later writers who knew the people of Algonquin Park thought Thomson might have been killed by an American he apparently hated.[2] A 1977 article by MacGregor in the *Toronto Star* suggests that Thomson was murdered, and that this was confirmed by the murderer's wife.[3]

This last version of Thomson's death draws upon an interview by an Algonquin Park warden with Daphne Crombie, who knew Thomson (see Appendix I, page 94). She was apparently told the story by Annie Fraser in November 1917 when she returned to the park (from Toronto) and asked Fraser what happened.[4] He was killed

at night during a drinking bout, said Fraser, by her husband, J. Shannon Fraser. They had quarrelled over money Thomson had lent: he had bought two canoes worth $250 for Fraser and though some or most of the money had been repaid, it had come back slowly. Thomson wanted the money to buy a new suit, perhaps to get married in. In the fight, Thomson was said to have fallen and hit his head on a grate (hence the bruise on his temple), knocking himself unconscious. Fraser, terrified at the thought that he'd killed Thomson, woke his wife and together they tied Thomson's feet with fishing line, packed his body in a canoe, paddled out onto the lake, dropped the body in, came back to the lodge, and set his canoe adrift. "It was nothing but that fight they had and Shannon's fist," said Crombie.[5]

Crombie was upset, and when she returned to Toronto, went to MacCallum. When she told him her suspicions, he didn't seem to listen. He spoke of the sale of a painting to the government for $500 (presumably *The Jack Pine*).

How can we evaluate Crombie's story? Such evidence as we have is conflicting and perplexing. The lost coroner's report pointed out that Fraser was the last man to see Thomson alive; he saw him about noon, Fraser said. The warden, Mark Robinson, thought he saw Fraser and Thomson together in a canoe the morning after the party, though at some distance.

From the evidence of the much later interview (reproduced in Appendix I), Crombie qualified her own words. "This is my conception," she says at one point. Yet from the evidence of telegrams, letters, and later articles, it is clear that Fraser's role after Thomson's disappearance was certainly an active one. When cottagers on the lake saw Thomson's empty canoe floating in the water, it was Fraser who wanted the warden to drag for the body. It was Fraser who sent a telegram, then a letter, to MacCallum the second day Thomson was missing. Then, when the body was found, he sent a telegram saying, "Found Tom this morning."[6] To Thomson's father he wrote to explain the death was an accident: "The Dr. found a bruise over his eye and thinks he fell and was hurt and this is how the accident happened."[7] It was Fraser who spread the gossip

that Thomson committed suicide, having contemplated the act for some time. Thomson, he said, was depressed at the thought of marriage to his girlfriend in Algonquin Park, Winifred Trainor. Trainor was coming to see Thomson to have a showdown, and Thomson felt he could not settle down.[8]

Fraser's stories seem close to the story his wife told Crombie: Fraser was the last to see Thomson alive, Thomson fell and was hurt, it was an accident. The rumour of an impending marriage to Trainor, and Thomson's feeling of panic, may also have been true.

Nevertheless, Fraser's insinuation that Thomson didn't want to marry her made Trainor so angry she went to Thomson's family. She told his sister that Thomson hadn't liked Fraser as he "hadn't a good principle."[9] Thomson's brother-in-law, Gordon Harkness, echoing her, said Fraser was "ignorant and without principle."[10] Fraser was devious, said Mrs. Crombie, and mercenary: he tried to sell Thomson's shoes after his death. In 1928, he offered three Thomson sketches to Hart House for $125 each. (Two were accepted.)[11] Crombie was ever afterwards convinced that Fraser had killed Thomson. He had a violent temper and people in the park were afraid of him. She believed that Annie Fraser had told her the truth. Annie was decent and honourable, says Crombie. "She never told me lies, ever."[12] My own contribution to the record is small. All I can add is that when I interviewed Crombie in 1971, specifically about Thomson's work, she was a careful witness.

If Crombie's story is true, Thomson's death was less murder than manslaughter – an accidental death caused by violence. Why wasn't there any fuss? A.Y. Jackson wrote: "It was not till years later when he had been acclaimed a genius that strange tales were told about his having been the victim of foul play."[13] At the time only a few knew the circumstances of his death; most were baffled. Newspapers said that his body was missing, then that it was found. He had drowned. People spoke of his having been killed by poachers: as a park warden he'd been known to have fierce arguments.[14]

MacCallum, perhaps due to his aloof nature or to his desire to leave Thomson's name unsullied, apparently kept

Crombie's suspicions to himself. Nor did Thomson's friends discuss the circumstances of his death in public. There was a further poignant dimension in what one must regard as a predictable reaction of the day; they disliked the unseemliness of what in time they may have come to feel was a misadventure. It was as if death by violence – as opposed to death from clearly natural causes – was tinged with a delinquency that lessened the man's character. Whatever happened, his friends felt his death somehow lacked dignity.

Anyone acquainted with Thomson's violent mood fluctuations and wild drinking would question the feelings of his friends. His hell-raising, anarchic individualism may have been another side of a depressive personality. But his fellow artists did not know, it seems, his dark side; certainly they have not recorded it, and it appears only in the records of youthful companions. Even if misadventure was not in their thoughts, the senselessness of his death was. Nor could any of them speak out frankly; they were bound by what became a taboo subject. No doubt this contributed to the sense of a close-knit band, which led to the founding of the Group of Seven. In this act of artistic self-creation, Thomson's genius and early death were the defining myth of their existence. The members of the Group of Seven were largely responsible for preparing the ground for Thomson's renewed reputation with the public. Fighting for his art was a way of fighting for their own ideals.

The key figure was A.Y. Jackson. In 1917 he was in England as a war artist, waiting to go to France. On the news of Thomson's death, he wrote MacDonald to say that in all the turmoil around him it was shocking "that the peace and quietness of the north country should be the scene of such a tragedy … It seems like the ruining of another tie which bound me to Canada."[15] Then Jackson launched into his often-quoted words about Thomson: "because without Tom the north country seems a desolation of bush and rock … My debt to him," he added, "is almost that of a new world, the north country, and a truer artist's vision."[16] That letter is crucial to our understanding of the Thomson myth. Facing the madness of world war, Jackson yearned for wholeness. Thomson, who had lived in virtual isolation in Algonquin Park, suddenly took on, in Jackson's eyes, a primitive splendour.

The North, too, had special resonance for Canadians sickened by Europe and its homicidal madness; more than before, the North seemed the soul of their country. Jackson spoke of it as a treasure trove of new motifs, a perfect place for the boys' adventure club which the early Group of Seven became.

By September, J.W. Beatty and other friends had raised a cairn to Thomson on a prominent point of Canoe Lake in Algonquin Park. MacDonald, both poet and lettering man, wrote and designed the inscription: "He lived humbly but passionately with the wild … It drew him apart and revealed itself wonderfully to him. It sent him out from the woods only to show these revelations through his art, and it took him to itself at last."

Those words designated Thomson as a kind of woodland god. They suggest the myth-making process that was now beginning. "Revealed" and "revelations" suggest the semi-mystical way Thomson's friends (and possibly Thomson) thought about nature. The "quest" was seen as a sort of communion with the spirit of the North. A more pedestrian but still glorified Thomson appeared in MacDonald's article, "A Landmark of Canadian Art," in the November 1917 issue of *The Rebel*. Describing the building of the cairn, MacDonald spoke of Thomson's "concentration of purpose, and his natural genius and knowledge, and sympathy with his subject."[17]

The same fall Dr. MacCallum, Thomson's old friend and patron, busied himself with the sale of Thomson's paintings (Fig. 65). He wanted to help the career of someone he considered a great painter, to assist as he had during Thomson's lifetime. He was thinking of a special collection in the National Gallery of Canada, as well as a memorial exhibition. The exhibit was held in December at the Arts and Letters Club in Toronto. George Thomson, Tom's brother, wrote Dr. MacCallum to suggest that the doctor appropriately title the larger paintings.[18] In the meantime, MacDonald had asked their usual framer, Charles Boughton, for a price on frames. As a dated note in a sketchbook shows, MacDonald ordered one hundred frames for Thomson's small sketches at thirty-five cents each.[19] He also framed two canvases, *Morning*, and one he called *Ice (Red Shores)*.

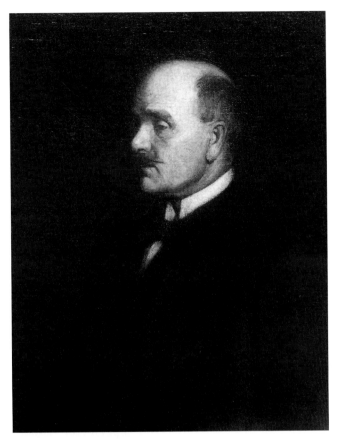

Figure 65
A. Curtis Williamson (1867–1944)
Portrait of Dr. J.M. MacCallum ("Lord Lonsdale"), c. 1917
Oil on canvas
76.5 x 62 cm
National Gallery of Canada, Ottawa
Bequest of Dr. J.M. MacCallum, Toronto, 1944

By 1918 the process of elevating Thomson was fully under way. C.W. Jefferys, in the Annual Report of the Ontario Society of Artists, said that the group "was the means of introducing Thompson's [sic] work to public attention, and desires to record its regret at the untimely ending."[20] In the same year in *The Canadian Magazine* MacCallum wrote of Thomson, "He lived his own life, did his work in his own way, and died in the land of his dearest visions."[21] His colour, said MacCallum, "sings the triumphant Hosannas of the joy and exaltation of nature."[22] He drew a picture of Thomson in nature: "Puffing slowly

at his pipe, he watched the smoke of his camp-fire slowly curling up amongst the pines, through which peeped here and there a star."[23] This vision of Thomson was to prove significant to later artists.

In 1919 his work was exhibited at the Arts Club of Montreal. Jackson, more plain-spoken than MacDonald, wrote the pamphlet essay. Thomson, he recalled, was equally happy when he "caught a big trout, when his bannock turned out well, or when he brought back a gorgeous sketch; [he was] a poet, a philosopher and a good friend."[24] In 1920 there was a large show of Thomson's work at the Art Gallery of Toronto. The anonymously written catalogue essay, awash with mysticism, expanded the myth: "Alone by his camp fire, the moon a silvery green pathway on the waters, the stars peeping through the solemn pines, he communed with the Spirit of the North, and straightaway was freed from the shackles of the town."[25] The inscription on the cairn was reproduced.

In the 1920s, Thomson became a standard part of major exhibitions. *The West Wind* travelled to Buffalo in 1921, to London in 1924, and to Paris where, in 1927, it was shown in an exhibition of Canadian art at the Musée du Jeu de Paume. The foreign press reacted favourably to Thomson's work, with some critics even suggesting what they believed to be the influences that shaped him. In 1924 *The Glasgow Herald,* for instance, noted that the patterning of *The West Wind* was in the "Japanese tradition,"[26] a questionable assertion.

Plans were also made to place major paintings in public collections. On an estate list, possibly from 1917, there is a record that Sir Edmund Walker, founder of the Art Gallery of Toronto, declared that "the museum will buy one painting [and I] ... will buy two for the National Gallery."[27] But Walker's promise did not materialize for nine years, when Thomson's friends and family almost had to force *The West Wind* on the Toronto institution.

In the years immediately following Thomson's death, the family had high hopes and began to set high prices. George Thomson suggested $30 for his brother's sketches, though he added that the price would be lower for the purchase of a group of works.[28] In 1918 the National Gallery of Canada bought twenty-five sketches at $25

each. Dr. MacCallum was asked to help fix the prices of the larger canvases and to consult with one or two artists, such as MacDonald, who were most familiar with Thomson's work. Sales were few. In 1921, when the Toronto Gallery had still not shown an interest in purchasing a work, Jackson suggested that *The West Wind* go to the National Gallery. The following year he suggested that the family price the canvas at $700 or $800. (By 1923 the family had decided on $1,500.)

Throughout this period Jackson and MacCallum vigorously prodded the trustees of the Art Gallery of Toronto to make them realize, as Jackson said, "that they should have one of the most important of Tom's canvases."[29] In a letter of 1922 Jackson wrote that the gallery was being reorganized and a Canadian room was promised; moreover, "The first picture we want in it is *The West Wind*."[30] Eric Brown, the director of the National Gallery, had wanted it, but Jackson believed it should go to Toronto, since all "Tom's associations in art were round Toronto" and the Group wanted "Thomson with them."[31] The gallery's funds were low, however, and usually spent on European work. *The West Wind* was finally bought for the gallery by the Canadian Club of Toronto in 1926, through the persuasive help of Dr. Harold Tovell of Toronto, influenced by MacCallum and Jackson.[32]

Thomson's friends did all they could to enhance the fame of the painting. In 1924 F. H. Varley could tell his gifted student Robert Ross that Thomson was already a legend.[33] Several of the Group used their writing talents to good effect in perpetuating the Thomson myth. Fred Housser, in *A Canadian Art Movement*, called *The West Wind* "northern nature poetry … which could not have been created anywhere else in the world but in Canada."[34] But as MacCallum said in a 1930 letter, "Housser never knew poor Thomson – never even saw him."[35] The myth had taken hold to such an extent that by 1930 MacCallum felt called upon to stake his own private claim to its creation: "You will find in an old *Canadian Magazine* about 1918 or 1919 an article on Thomson by me – it has been the source from which all the articles about him have been drawn," he told a friend.[36]

Artists who had never known Thomson joined in the blossoming celebration of his genius. There was something rich about his work, something modern, which combined high art and moral seriousness about Canada. From Fred Haines, principal after MacDonald of the Ontario College of Art (and owner of two Thomson sketches), to Pegi Nicol MacLeod in the 1930s, later artists found in Thomson's work a seemingly inexhaustible source of motifs (Fig. 66). Now Thomson seemed to belong to an idyllic picture of the North, to a classic Canadian culture, and Algonquin Park to the tradition of the enclosed garden (albeit a wild one), a stronghold in the face of the encroachment of foreign influence (mostly the United States).

Much later, in the 1970s, Thomson was claimed again for the cause of nature and the North. In part this was the result of a leading strain of Thomson criticism produced by a generation of art teachers and students: what we might call the Lyric Landscape Party line. It was also due to writers such as myself and Harold Town, who saw Thomson as primarily an exciting painter whose abstract and painterly qualities were as crucial as his subjects. By the early 1980s, his work again seemed to fit the dominant political agenda in art: abstraction was on its way out, naturalism on its way back. Due to the re-emergence of representation in art, under the auspices of Post-Modernism, middle-class ideals of art were, radically this time, reinstated, middle-class culture re-examined, even back to the time of its emergence. In Canada, artists thought of Thomson.

In autobiographical comments, they re-imagined Thomson not as a precursor of the Group of Seven but as a Canadian innocent driven by obsessive concerns. Usually his sketches were preferred to his major canvases – they were "intuitive" and "passionate," whereas, following a convention we often find in art history, the larger works were often said to be influenced by suggestions from other artists. Best of all was Thomson's life "in nature." Painters such as David Alexander of Saskatoon claim to spend as much time in nature as possible; he draws on his experience for his work (Fig. 67). Alex Cameron of Toronto, consciously following Thomson's

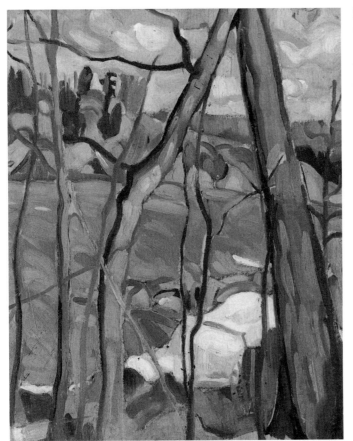

Figure 66
Pegi Nicol MacLeod (1904–1949)
Winter Landscape, c. 1931
Oil on plywood
33.8 x 28.8 cm
Private collection, Whitby, Ontario

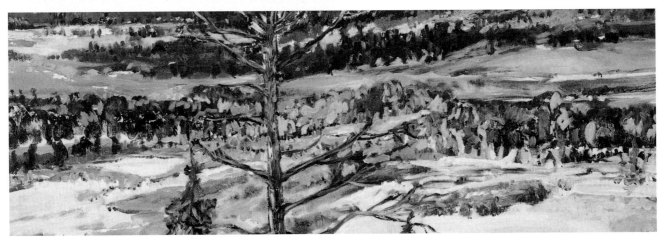

Figure 67
David Alexander (b. 1947)
Stretch, 1988
Acrylic on canvas
43.5 x 124.6 cm
The Robert McLaughlin Gallery, Oshawa. Gift of Joan and W. Ross Murray, Whitby, Ontario

example, made sketches in nature which he used as the basis for paintings like *Bush Country* and *Flooding Above the Dam* (Figs. 68–69). Richard Gorman also thought of Thomson's work as a model as he painted in his Toronto studio memories of the Limerick Lake area near Bancroft, west of Ottawa, and of the Ottawa River, often at dawn or when rich colour is in the sky. Rae Johnson saw in Thomson an artist who came to grips with northern light. In paintings of her pond in Flesherton, Ontario, and elsewhere, as in North Bay, she studied natural light and reflection. Her study of the natural world became a grounding device for all her work. Joyce Wieland and John Boyle were at the other end of the spectrum. Both used the Tom Thomson legend to underscore their consuming interest in myth. Wieland presented Thomson as the artist hero in her film *The Far Shore*, then in her later watercolours had him make love to her "goddess," a central figure of her art (Fig. 70). John Boyle introduced his figure into his portraits of Canadian heroes, mythical figures, and Boyle himself.

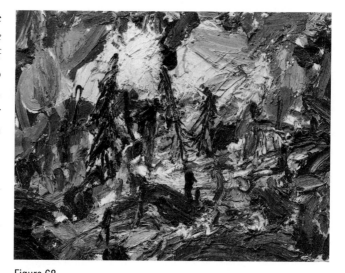

Figure 68
Alex Cameron (b. 1947)
Bush Country, 1987–88
Oil on canvas
45.5 x 61.0 cm
Private collection, Whitby, Ontario

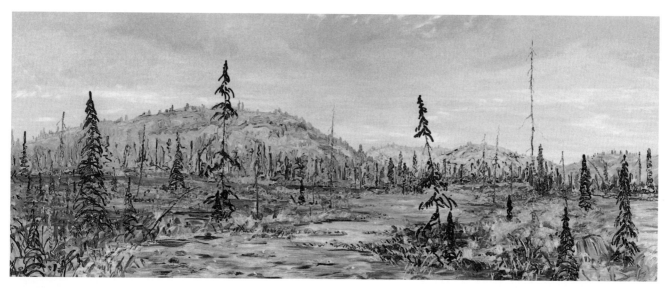

Figure 69
Alex Cameron
Flooding Above the Dam, 1990
Oil on canvas
122.1 x 305.6 cm
The Robert McLaughlin Gallery, Oshawa

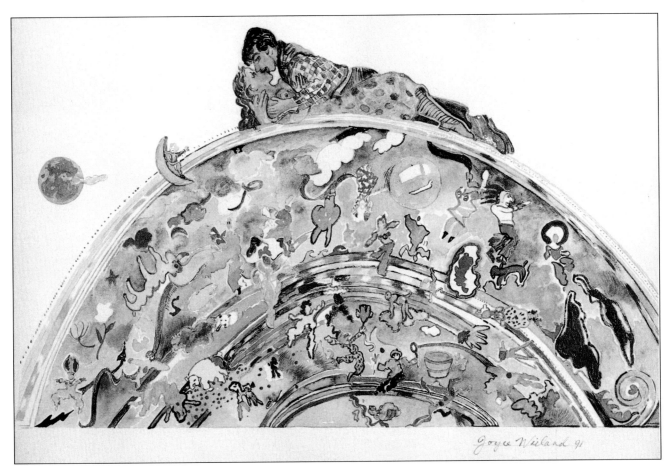

Figure 70
Joyce Wieland (b. 1931)
Tom Thomson and the Goddess, 1991
Mixed media on paper
28.0 x 38.1 cm
The Robert McLaughlin Gallery, Oshawa

Some artists have gone beyond a formalist study of Thomson's work, seeing it less as an ennobling vision than as a way of providing a kind of legend, with an unconscious vision of its own. Gordon Rayner has found this view amenable to his own free-wheeling subversion of the canvas; Michael Snow has used it in his reconstruction of the world in his Ektacolour prints. Despite his idealistic statements about Thomson's work, Rayner's large *Drowning* canvases show objects that might have been washed up on shore after Thomson's death: a ruler, an old shirt, and even an old black felt hat (Fig. 71). "I've always wanted to do a series of peculiarly *Canadian paintings*," says Rayner.[37] Thomson provides the armature of myth. Snow, in *Plus Tard* (1977), used photographs of *The Jack Pine*, among other works by Thomson, to indicate how we might see them displayed at the National Gallery of Canada. His was a film camera view: the paintings were blurred and out of focus. The photographs he took included the labels, the walls, and doorway of the gallery: an apt metaphor for the way we recall works of art — in their settings.

Thomson today provides an example of a politically and environmentally innocent countryman for the 1990s. As the news about our environment grows more dire, artists – and we, the public – respond with growing eagerness to Thomson's work and to those who replay that imagery or myth. Our reaction is not only a form of escapism, of nostalgia for a simpler, better time, but has become, it seems, an essential part of being Canadian. To meditate on Thomson or his memory refracted through the work of the many artists influenced by him is a way of tapping into the tradition of Canadian culture before taking up the burden of the international present. His is a powerful image; he represents a "natural" painter for us, one we study in relation to a political and economic community that is fundamentally urban. He represents our longings, not our realities.

In the future, since Thomson's works are not deposits of fixed and final meaning for us to decipher, but rather charges of psychic energy to be recycled by every generation according to its own needs and will, artists will continue to reinterpret the myth of Tom Thomson. His death, which the Group of Seven sought to redeem, has become a compelling Canadian myth; and his work receives less analysis than homage. Artists create, in the telling of Thomson's influences on themselves, works that provide a juxtaposition and at the same time a fusion of their own vision of Canadian art with that of an earlier day.

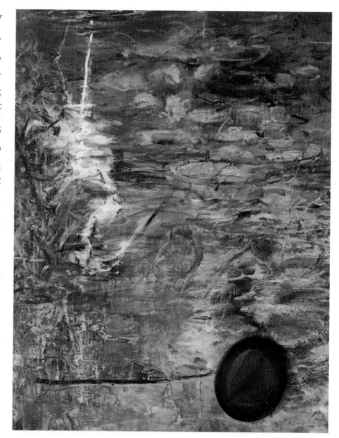

Figure 71
Gordon Rayner (b. 1935)
Evidence II (Concerning a Drowning in Canoe Lake), 1989
Acrylic and felt hat on canvas
160.9 x 125.7 x 10.5 cm
The Robert McLaughlin Gallery, Oshawa

Chronology

End of March through first half of April 1917	Thomson arrives in Algonquin Park and stays at Mowat Lodge: lakes frozen over, 2–3 feet of snow in the bush.
21 April	Warm weather; ice still on lakes; thunderstorm clears off snow – "just patches left."
23 April	Thomson expects ice to "go out"; 1–2 feet of snow on north side of hills.
28 April	Thomson buys Guide's License.
6–8 May	Weather "fine and warm."
24 May	Dr. MacCallum and son Arthur (arrive?) for fishing trip. No snow left; weather is cold. (Interview with Arthur MacCallum, 24 November, 1993.)
28 May	Dr. MacCallum back in Toronto.
4 (?)	Thomson asks Mark Robinson if he can hang sketches in his cabin.
7 July	"Second warm day."
8 July	Thomson goes fishing.
16 July	Thomson's body found by George Rowe.

Appendix I

From the Archives

1. "Pictures by Sydenham Boy Worth Seeing," *Owen Sound Sun*, 10 April 1917
2. Letter from Margaret Thomson (later Mrs. Tweedale) to Joan Murray, 2 August 1971, Joan Murray, Tom Thomson Papers, The Robert McLaughlin Gallery (hereafter JM, TTP)
3. Letter from Tom Thomson to his father, 16 April 1917, Tom Thomson Collection, National Archives of Canada (hereafter TTC, NA) (MG 30 D 284, Vol. 1)
4. Letter from Tom Thomson to Dr. James MacCallum, 21 April 1917, TTC, NA
5. Letter from Tom Thomson to S.J. (Tom) Harkness, 23 April (postmark) 1917, TTC, NA
6. Guide's License, 28 April 1917, TTC, NA
7. Letter from Tom Thomson to Dr. James MacCallum, 8 May 1917, TTC, NA
8. Letter from Dr. James MacCallum to Tom Thomson, 28 May 1917, TTC, NA
9. Letter from Tom Thomson to Dr. James MacCallum, 7 July 1917, TTC, NA
10. Letter from Mark Robinson to Blodwen Davies, 23 March 1930, Blodwen Davies Papers, National Archives of Canada (hereafter BDP, NA)
11. Excerpt from a hand-written account of Mark Robinson, c. 1930, Ottelyn Addison, Richmond Hill, Ontario
12. Excerpt from an interview with Mark Robinson by Alex Edmison, Algonquin Park, 1952, JM, TTP
13. Interview with Daphne Crombie by Ronald Pittaway, 14 January 1977, Algonquin Park Museum Archives

1.

Owen Sound Sun
10 April 1917

PICTURES BY SYDENHAM BOY WORTH SEEING

Mr. Tom Thomson's Pictures Show
Decided Talent of Promising Artist

In every report concerning pictures exhibited by Ontario's artists in Toronto for the past few years there has been a paragraph or sentence which, without exception, was one of praise for the pictures shown by Mr. Tom Thomson. He has been spoken of by the highest art critics as a young artist who is on the threshold of an exceptionally brilliant career, and any work he shows always receives marked praise. Mr. Thomson's success is of interest to Owen Sounders, for his parents reside on Fourth Avenue East, and he himself is a Sydenham boy, having lived in Leith for many years. A member of The Sun staff had the pleasure, while in Toronto recently of paying a visit to Mr. Thomson's winter studio in Rosedale, and the visit was all that was needed to convince one that Mr. Thomson is indeed an artist whose name will be much before the public in coming years.

Mr. Thomson's paintings are almost entirely of nature. Only in a few instances does he introduce figures, and then not with great success. But his studies of landscapes, water, clouds and trees are wonderful, both for their faithful representation of the subjects and for the unusual and even marvellous color effects. Mr. Thomson has simply hundreds of sketches, not on canvas but on boards about 9 in. by 10 in. From these he makes the larger canvases, such as the ones the Dominion and Provincial Governments have bought from him for public buildings. Seen in the small studio these could not be appreciated but when hung in proper surroundings they would no doubt be admirable.

When the artist first begins to place his smaller pictures before one, one is apt to find them too full of color – for Mr. Thomson's use of color is what makes his work notable. There are wonderful autumn scenes, the crimson and burnished golds of leaf and vine being transposed almost too faithfully, one is apt to say at first, to canvas. There are studies of wild flowers which are exquisite and ones of rocks and still and running water which are wonderfully attractive in their color and in their character. When one has seen forty or fifty of them, there is a change in the visitor's appreciation. The color begins to grow upon one. It is all true to nature, the kind of thing you look at in field of forest and say, "See how brilliant that is. If it were transferred to canvas some would say that the artist exaggerated." And though at first the brilliancy rather daunts one, before the end is reached the real art in the canvases becomes apparent and the duller canvases are tame. There was one picture which the guide of the writer secured for his own. It was a study of a flat field, and two trees. One's leaves were of a flat mahogany, beech red. The other was a flaming yellow – the yellow of a birch on a certain kind of soil. When we first saw this the yellow and red seemed to – well, scream to us. But when we had looked at it for several minutes, the grace and living fires of the trees – hundreds of times had we seen them as vivid – began to dawn on us and before we went we knew the picture was a treasure.

Mr. Thomson's studies are nearly all made in the North Country. There are a few from this vicinity, but he finds more of the abundant color he loves in the wilderness of the northern forests, and besides, the life he is able to live there – the simple life in every truth – appeals to him. Those who are interested in pictures would greatly enjoy a visit to Mr. Thomson's studio, and there would be few who would come away without a great deal of praise for the work of the artist.

2.

Letter from Margaret Thomson (later Mrs. Margaret Tweedale), 2 August 1971, JM, TTP

45 Allonsius Dr.
Etobicoke, Ontario
Aug. 2nd 1971

Dear Mrs. Murray,

I am very sorry I could not have met with your request earlier, but I was not well enough to go and see what was in the basement in the large box.

My husband had rearranged things and put what he had gathered through the years in with my clipping of Tom and George. There were letters from different ones of the family and Uncle Alex's letters, our marriage artifacts – educational certificates, recommendations, wedding pictures and articles. It was all very interesting but very touching. In among all these things were Tom's letters.

Both of these letters were written in 1917. One on the 23rd of Jan. 1917 and the other on April 16th. 1917. Father had put these letters in a safe place in his secretary, and it had been my duty to attend to everything. I realized they were valuable and in looking them over, I noticed there is special mention of his work for that period of time.

He went up earlier as he wanted to get more ice and snow pictures. The winter before he was very busy making large paintings from his sketches.

He said, "I am staying at the post office until the ice goes out then I will start to camp.

"I did not send any paintings to the O.S.A. exhibition this year and have not sold very many sketches but think I can manage to get along for another year. I will stick to painting as long as I can. I got quite a lot done last winter and so far have some pretty good stuff. Is nice I came here and I expect to do a great deal further between now and June.

"Have not decided whether I will stay here the whole summer or not.

"Hoping you are all well. I remain your loving son.

Tom Thomson."

Tom was home for Christmas and saw all his old friends. There was a dance in the Leith Hall. My sister Elizabeth and her husband Tom Harkness were there. Tom had a grand time and was very happy. They joked him about his potatoes and other vegetables and fruit and told him they would all freeze in the shack but it didn't bother him at all. I wasn't there as I was quite ill. The others had flu. He

wanted to get home for a day or two but he just couldn't make it as he was so anxious to get the snow and ice pictures.

Mrs. Murray, you mentioned something about two pen and ink pictures. I can not remember whether not they were done about the same time, but I think they were. He brought them home to mother and father one Christmas. They were terribly delighted with them! They prized them greatly.

We are so delighted your exhibition is going so well and that the interest is high. We all wish you every success. You have worked very hard and deserve appreciation.

Sincerely,
Margaret Tweedale

3.

Letter from Tom Thomson to his father, 16 April 1917, TTC, NA

Mowat P.O.
Algonquin Park

Dear Father: I have been up here for two weeks making sketches. Had intended going up home for a day or two before coming here but wanted to be here before the snow was gone so could not spare the hour. The lakes are still frozen over and will be for two or three weeks yet and there is still about two to three feet of snow in the bush so I expect to get a lot more winter sketches before the snow and ice are all gone. Tom Harkness and Walter Davidson were in to see me the day before I came here also Mrs. Andrews and Low Julian (I don't know if the last name is spelled properly or not) but I don't think they enjoyed the show a great deal as they are taking lessons from Manley the worst painter in Canada.

Am stopping at the Post Office here until the ice goes out when I will start to camp again. have tried fishing thro the ice two or three times but have had no success yet have caught some `ling' which is a cross between an eel and a fish but they don't use them up here.

I did not send any paintings to the O.S.A. Exhibition this year and have not sold very many sketches but think I can manage to get along for another year at least I will stick to painting as long as I can.

I got quite a lot done last winter and so far have got some pretty good stuff, since I came here and expected to do a great deal between now and June.

Have not decided if I will stay here the whole summer or not. Hoping you are all well. I remain your loving son.

Tom Thomson

4.
Letter from Tom Thomson to Dr. James MacCallum, 21 April 1917, TTC, NA

Mowat P.O.
Apr 21 (1917?)

Dr. James McCallum

Dear Dr.: I have been here for over three weeks and they have gone very quickly. For the last two or three days the weather has been fairly warm and last night we had quite a heavy thunder storm and the snow is pretty well cleared off. just patches in the bush on the north side of the hills and in the swamps so now I will have to hunt for places to sketch when I want snow. However the ice is still on the lakes but it is very thin this year on account of deep snow over it through the winter so it will not last very long.

If you can come up hear this spring – I think we could have some good fishing and the animals are more plentiful on this side of the park than where we were last spring. I would suggest that you come some time around the tenth 10th of May as the flies are not going properly until about the 24th.

It is likely that the ice will be out sometime this month.

Have made quite a few sketches this spring. have scraped quite a few and think that some that I have kept should go the same way. however I keep on making them.

Yours truly
Tom Thomson

5.
Letter from Tom Thomson to S.J. (Tom) Harkness, 23 April (postmark) 1917, TTC, NA

[c. April 23, 1917]
Mowat, P.O.
Algonquin Park

Dear Tom, I have been here over three weeks and have done considerable work for that length of time.

I got a copy of the O.S. Sun and it seemed to be well filled with bunk, however the foolishness of newspaper matter is well known and I knew nothing about it in time to have it stopped.

I have been talking to the people here at the Post Office about paintings. Had been advising them to get about 6 or eight small ones and keep them till fall, which they could do without much expense and hang them up for the winter.

Supposing they desire to try it out, what would they have to pay for the paintings and where would be the place to send for them – and could they be shipped by express or freight any distance.

Am staying at the P.O. until the ice goes out of the lakes which I expect it to do sometime this week then I will be camping again for the rest of the summer. I have not applied for the firerangers job this year as it interferes with sketching to the point of stopping it all together so in my case it does not pay. In other words I can have a much better time sketching and fishing and be further ahead in the end.

I may possibly go out on the Canadian Northern this summer to paint the Rockies but have not made all the arrangements yet. If I go it will be in July & August. We still have a foot or two of snow on the north side of the hills yet but another week will see the end of it, and we have nearly my friends the black flies are here, the leaves do not come here until May 24th and often not until or in June.

Well I will get this started towards Annan hoping you are all well there. I remain

your aff. brother
Tom Thomson

6.
Guide's License, 28 April 1917, TTC, NA

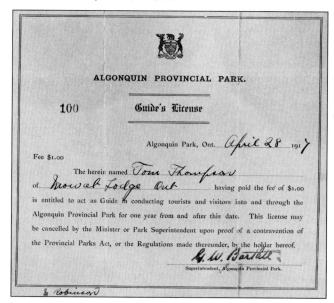

7.
Letter from Tom Thomson to Dr. James MacCallum, 8 May 1917, TTP, NA

MOWAT LODGE
J.S. Fraser
Mowat P.O., Canoe Lake Station
Algonquin Park, Ontario

Mowat P.O., Ontario May 8 1917

Dr Maccallum

Dear Sir: Could you not stop off at Canoe Lake on your way up. it is eight miles this side of the Highland Inn and is the best starting point going either north or south. If you wanted to see the outfit at Cache Lake would you come back to Canoe Lake on the

afternoon train which leaves there at about 2.30 PM. and you would be back here in about 20 minutes otherwise I would have to pack the outfit over about 2 or 3 miles portage and we would have it back again where we could see the same places from Smoke Lake going light.

You can get any extra blankets or stuff from Fraser. and I have all the supplies including 1 gallon maple syrup, pail of jam plenty bacon, potatoes, Bread tea, sugar, all kinds canned stuff, tents canoes cooking outfit plates etc) I tried to get some chocolate and failed have no "Kilm" & no Coffee that I think is Everthing we need for two or three weeks including Williamson. the weather for the last two days has been fine and warm.

Will expect you either Friday or Saturday and will not go over to Highland Inn unless you want specially to start out from there.

If the weather is bad we may arrange to get in one of the Rangers shelter Huts.

Yours truly,
Tom Thomson

8.
Letter from Dr. James MacCallum to Tom Thomson, 28 May, 1917. Envelope postmarked 28 May 1917, TTC, NA

Toronto 28/V/17

Dear Tom.

We got home all right – made a good connection at Scotia Junction having only to wait for a half hour. I have deposited to your credit a cheque for $25.00 given me by Bill Beatty for a sketch of yours which he had sold to some chap from Sorth River. All the fellows backed down and I had to go up to the Georgian Bay alone, returning last Saturday. Had a rotten time of it – snow, rain, sleet, more snow and only two decent days the whole week. Vegetation is not nearly so advanced as in the Park – I quite understood why you prefer to paint up there – the two places are *so* different. In the Georgian Bay there is in the spring practically none of the brilliant colour from the vegetation of the Park – There were really only two soft maples in bud while I was there – The birches have not even begun to change – all day the water was beautiful a fresh wind and a good sea into clear sky – I have not seen any of the chaps yet to find out what the news is. You had better send down a lot of those sketches of yours as soon as you start in guiding and see if I cannot sell some of them and increase your bank account – remember me to the Frasers and their guests. Must close and get to work.

Yours
James MacCallum

9.
Letter from Tom Thomson to Dr. James MacCallum, 7 July 1917, TTC, NA

MOWAT LODGE
J.S. Fraser
Mowat P.O., Canoe Lake Station
Algonquin Park, Ontario

Mowat P.O., Ontario, July 7 1917

Dr. MacCallum

Dear Sir: I am still around Frasers and have not done any sketching since the flies started. The weather has been wet and cold all spring and the flies and mosquitos much worse than I have seen them any year and fly dope doesn't have any effect on them. This however is the second warm day we have had this year and another day or so like this will finish them. will send my winter sketches down in a day or two and have every intention of making some more but it has been almost impossible lately. have done a great deal of paddling this spring and the fishing has been fine. Have done some guiding for fishing parties and will have some other trips this month and next with probably sketching in between. Received this slip of paper a day or so ago and don't know anything about it. Would you give it to Jim McDonald or someone around the bldg. with permission to do anything about it they see fit. If they will I will be greatly obliged.

Hoping you are well – I am :

Yours truly
Tom Thomson

10.
Letter from Mark Robinson to Blodwen Davies, 23 March 1930, BDP, NA

To Blodwen Davies Brent P.O. Ontario
21 Prince Arthur Ave. Via North Bay
Toronto, Ontario March 23 1930

I have your letter of March 11th which was delayed in reaching me, hence delay in answering. Yes, I knew Thomas Thompson very well we *were friends* and spent many happy hours on the trail and by the camp fire, discussing the beauties of nature. the wild friends of the forest, fishing etc. Tom was a study at all times one day he was jovial and jolly ready for a frolic of any kind so long as it was clean and honest in its purpose. At times he appeared quite melancholy and defeated in manner. At such times he would suddenly as it were awaken and be almost angry in appearance and action. It was at those times he did his best work. He would quite often come dashing into My Cabin and in an excited tone ask about certain rocks or trees or rolling hills. I will mention one instance as an example.

We saw Tom come almost at a run over the Joe lake portage, Canoe over his head. Throwing his canoe into the water he seized his paddle and shooting the canoe out into the water paddled like a mad man to our wharf. Here he pulled up his canoe in haste and up into our cabin. Say Mark you know. I know you know just what I want, three trees. Spruce trees, black spruce rough old looking trees you know what I mean. trees again[st] a cold green grey northern sky where I can get them at once. I said Tom just tell me what you

want and possibly I can help you. He then described the two black spruce trees. I said go to the little wharf below Simms Pit you will find those trees you want in a grove. But can I get them against a cold northern sky? I assured him that I thought he could. He was away like a shot and like a wild man was disappearing over the portage. Three days later Tom came into our cabin. There was a big smile on his face as he said, say Mark, those trees were just what I required for my canvas, and the sky just right. How do you always know what I want. I could only tell him, Tom you describe things so accurately it's no trouble to remember the odd things we see every day. On another occasion he required an old Rampike. I set him to Hickeys Lake. Just what I was looking for, he said a week later Makes a fine canvas. I did not see either of the above pictures. We spent many happy hours looking at old tree stumps etc. One day we were looking at a White Birch tree and I said Tom it would be rather hard to get all those old snarls in with the Brush. Not at all he answered, and a few days later he showed me a canvas, almost perfect in copy of the living tree. On another occasion we were looking at an old Pine stump that was partially covered with moss and the grey colour of the wood was of many shades of grey, he looked at it and said there is one of the hardest things to paint in the woods, see those different shades of grey. A artist must get them in perfect or the sketch is a fraud on the public there aren't more than two or three in every hundred who will notice it but [if] it's Not true to Nature and imperfect Notes destroy the soul of music so does imperfect colour destroy the soul of the canvas. I mention these facts just to show the honest purpose of Tom's views on the different things in life. The spring before his untimely death he painted a canvas a day showing the various stages of the advancing spring and summer. He was very fond of this work and one day dashing into my cabin he said may I have my records on those walls for the summer. I assured him that he could but death stepped in and they were never hung. I saw a great number of these canvases they were good. I think Tom's brothers and sisters got most of them.

Tom was an excellent woodsman, canoeman, swimmer and guide, and many a sick friend Tom paddled around fishing and growing strong and back to health again and would take no remuneration of any kind he was an ardent fisherman and loved to capture some very old trout that fooled the best fisherman. For about ten days before his death there were several of us trying to invent a lure that would entice a wily old trout that frequented a pool below Joe Lake Dam. Tom was there every day and several times had hooked the trout but never landed him. I had about the same luck and it was a good natured contest as to which of us would land the trout. On the morning of his death he almost got the old trout and as he missed it he said I am going to one of the little lakes and get a trout and put it on Mark's doorstep early in the morning and he will think its the old fish from the dam. He went to Mowat Lodge of the Tainor cottage got a few supplies and left to get the big fish at one of the little lakes. J. Shannon Fraser Canoe Lake P.O. Ont. was at the lake as Tom left and was the last man (as far as the public know) to see Tom alive. He left at about 12:50 p.m. and at the inquest it came out that Marten and Bessie Blecher, American German tourists with Cottage at Canoe Lake Ont. found Tom's canoe floating not 3/4 of a mile from where he started out from the Trainor cottage at about 3 p.m. An east wind was blowing and this canoe could not have been there under ordinary conditions. They did not report finding the canoe until the following morning when the canoe was brought in from behind Little Wopomeo Island.

There J.S. Fraser reported the matter to me and at once I passed the show on to Supt. Geo. W. Bartlett who like myself refused to believe Tom was in the lake but might be lost in the woods with a broken leg. He ordered a search to be made and I kept it up until his body was found by Geo Rowe Guide of Canoe Lake P.O. Ont., and Dr. Howland of Toronto in Canoe Lake not far from a rocky point. On the west shore of Canoe Lake and almost equal distance between the two Wopomeo Islands I assisted Roy Dixon undertaker of Sprucedale Ontario to take the body from the water in the presence of Dr. Howland. There were no marks on the body except a slight bruise over the left eye. His fishing line was wound several times around his left ankle and broken off there was no sign off the rod. His provisions and kit bag were in the front end of the canoe. When found the lake was not rough. We buried his remains in the little cemetery at Canoe Lake, Martin Blecher Sr. reading the Anglican funeral service at the grave. Later his remains were taken up and went to Owen Sound for burial. Dr. Ranney of North Bay conducted what inquest was held. Tom was said to have been drowned. It may be quite true but the mystery remains.

He made his home at Mowat Lodge a good part of the time. Taking frequent trips into the fields alone. At such times he would call in and state the date he would return if all went well with him. He always would report at the time stated and usually be in the greatest good humour and have many pleasing little events to talk about. On those trips he would look for the wildest looking places possible and finding some rugged or desolate Point with a few knarled red Pine with a stunted look he would camp close by to see just how it would look in a storm and study the colour etc. His sketch The West Wind is the result of one of those wandering trips into the wilds of the park. Now I have mentioned a few things that will not do for a book but I feel you would like to know. So as to write to a better advantage. A few friends follow.

Miss Trainor of Huntsville Ontario to whom it was said that Tom was engaged. Could tell you a lot of fine things about Tom if she will talk.

Ed Godin Park Ranger, Achray Stn. C.N.R. Ontario Via Pembroke Ont: Tom put up with Ranger Godin when in that section of the park.

J. Shannon Fraser and wife of Canoe Lake Ont. and daughter Mrs. Arthur Briggs all knew Tom extra well and if Fraser will tell the truth much could be got from him but weigh well his remarks.

You might interview Martin and Bessie Blecher but again be careful. They possible know more about Tom's sad end then any other person. Canoe Lake P.O. Ontario.

Edwin Thomas and wife Kish Kaduk Lodge Govt. Park Station. Knew Tom very well and were reliable friends of Tom's.

Geo Rowe Guide who is quite aged now was a good friend of Tom's and many others who have moved away and I do not know where they are.

I hope I haven't bored you with this letter and with best wishes I remain
 Yours truly

 Mark Robinson
 Chief Ranger
 Brent. P.O. Ont.
 Via North Bay

11.

Excerpt from a hand-written account of Mark Robinson, c. 1930, Ottelyn Addison, Richmond Hill, Ontario

… Two days later I was called to share in the great adventure and did not see Tom until the spring of 1917 he had arrived at Canoe Lake a few days ahead of my return. Tom and a young man named Charles Scrim of Ottawa called at our Cabin. We spent the afternoon recalling past events – the following evening Tom walked in quite excited and referred to a very unusual display of Northern Lights. He would warm himself then go out until Chilled return and when warm out again to watch the display. Suddenly he said good night and he was gone. The old ranger then stationed with me remarked he is a very strange Man. What is he going to do now? The next day he had the Northern Lights sketched. The Night was very cold and how he Managed to Paint was a Mystery. Tom was pleased with the results.

Two days later the Morning was intensely Cold the Northern Sky was green in Colour. Tom walked in with a bang at daylight. Walked up and down the floor a few times then inquired where can I get them, find what I asked … You know then a couple of turns around the Room said I want to get about three Black Spruce against that northern sky. I do not wish for nice trim trees would prefer tall irregular rough tops. I advised him to go to Sims Pit and follow the old trails to Canoe Lake there and turn to the left to Sims Creek then north up the banks of the stream look to your left there are several Black …

12.

Excerpt from an interview with Mark Robinson by Alex Edmison, Algonquin Park, 1952, JM, TTP

[One night] he came bounding into the house about half past nine, and he [said], "did you see the Northern Lights?" Yes Tom, I said, they're very brilliant tonight, and he'd warmed his hands and out he'd go and stand and I kept on a roaring good fire and Tom would come in and warm his hands again – far below zero – and come in and warm his hands, out he'd go and just gaze at them. Finally about half past 11, about 11:30 it would be, he, I said, "I believe I can put that on canvas." Alright Tom, I said, here's the fire, and I said, I'll keep a fire on for you and everything like that if you wish to put it on canvas. "Oh, we haven't got a background here." Now he had an idea right there of a background that he wanted for that picture. If you look in the … If you look in the Algonquin Story, there's a reproduction of … in it of that … that particular night … of that … of the … *Northern Lights*. He went down to the … right down here … up here a little piece, there was a little cottage stood on a point, Lowrey Dickson had a lease there and built a little cottage that he and George Rowe used, and in that cottage was a stove and , oh it was comfortable, warm, and a supply of wood was always kept in there, dry wood. He put on a fire, he'd went to Fraser's and got his paints and he went at it and he did the *Northern Lights* sometime between that and morning. 'bout 8 o'clock in the morning he appeared at our place and produced it. "What do you think of it?" Now that *Northern Lights* was painted by lamplight, in fact most of it, and walking out and looking at it, and then going back into the house again. How he did it I'll … no one knows but

Tom Thomson, but because it was intensely cold and intensely cold the next morning when he came to our place and showed us what he had done. Now as we … as he went on and a few days … not … no … not such a few days but several days later, he … oh it would be weeks, couple or three weeks later, he came in at the house one day and he looked around, "You know," he says, "I have something unique in art that no other artist has ever attempted," and I can hear him, "I have a record of the weather for 62 days, rain or shine, or snow, dark or bright, I have a record of the day in a sketch. I'd like them … to hang them around the walls of your cabin here." Well, Tom and I had a little talk and I assured him that he'd be welcome to do so if he'd accept the responsibility as I couldn't do so, and I wouldn't be present..present probably all summer. Never knew when I'd be called away and some of them might disappear and I wouldn't feel that I would be responsible. He said "I'll accept all responsibility and I'll hang them around the wall here one of those days." I think that was about four or five days before he disappeared, and as we discussed it – the hanging of those pictures fully – he mentioned some other sketches he had made …

13.

Interview with Daphne Crombie by Ronald Pittaway, 14 January 1977, Algonquin Park Museum Archives

C. What am I saying that would be worthwhile?

P. You are probably one of the few people alive who knew Tom Thomson, and you were at Canoe Lake when Tom was there, especially in the winter months when people become quite intimate when they are living together as you have said. You have a good understanding of who Tom Thomson was especially before and after the aura developed. There may be a lot of mystique revolving around his life right now. I'd like to hear the story behind the story about Tom. Could you tell me about Tom Thomson and Winifred Trainor?

C. I could start in by Annie (Fraser) and I having a walk, and about the letter she had read and about Winifred's desire to come up the following week. She said, "Please Tom you must get a new suit because we'll have to be married." This came right from the mouth of the horse, if you will. She read this letter you see. Anyway, she did come up and when she came up, Tom had been drowned in the lake. Previous to that, Tom and George and another guy had a party. They were all pretty good drinkers, Tom as well. They went up and had this party. They were all tight. Tom asked Shannon Fraser for the money that he owed him because he had to go and get a new suit. The family doesn't like all this stuff to come out. Anyway, they had a fight and Shannon hit Tom, knocked him down by the grate fire, and Tom had a mark on his forehead. I don't know where it was. Annie told me all this and also Dr. MacCallum. Tom was knocked out completely by this fight. Of course Fraser was terrified because he thought he'd killed him. This is my conception, and I don't know about other people's. Although he was a big heavy Irishman, he was timid about those kind of things, devious if you know what I mean. My conception is that he took Tom's body and put it into a canoe and dropped it in the lake. That's how he died.

P. So you think Shannon Fraser may have killed Tom Thomson?

C. I know he hit him, but I don't think that he was dead. I think he might have been unconscious. Shannon Fraser was terrified that he was dead. I believe that Annie helped him pack the canoe and he went off into the lake with Tom's body, because she always helped him pack his canoe quite often.

P. That is Annie Fraser?

C. Yes. The daughter was away at school. She was a big tall red head just like Fraser, awkward and not at all good looking. Annie had skin just like a baby's. She was kind, decent, and very honourable. She never told me lies, ever.

P. How did Martin Bletcher ever get involved in this?

C. He used to come over to Mowat Lodge and we used to sit around. He was of German background and had a sister living there. Whenever he had nothing to do, he'd come over and sit down and we'd talk. Of course Tom would go over to the farthest corner of the room where there was no light. He didn't join in so much. I don't think Bletcher had anything to do with it. It was simply a myth to me. They never saw one another during the day, and they didn't seem to have any antagonism towards him. I'm damn sure that Winifred never went with Bletcher. He was an unattractive blowzy sort of individual. He had a German accent. Why he was living up there, I don't know.

P. Did Tom and Winnie see much of each other when they were at Canoe Lake?

C. Oh yes. He was with her all the time when she was there. She wasn't always there. When she went home again, she wrote him and told him to get a suit, they had to be married. Annie told me from her own lips having read the letter. Annie and Shannon are dead. The daughter doesn't know anything about it. The family were well removed from Mowat Lodge. They didn't come up when we were there at all, not all winter when we were there. She used to come up in spring when it was passable and you could get around.

P. Why didn't Winnie ever say anything about Tom Thomson after he died? She never officially said she was engaged to Tom Thomson or even going out with him.

C. The family was like that. They didn't want anything repeated at all, according to Annie. Then all this about that must have been Shannon putting somebody else in his coffin, and all that kind of stuff. I don't know what happened after they picked him out of the water because I wasn't there. I do know that we were there shortly before that, and I went down to MacCallum. The first thing that MacCallum said was you don't think he committed suicide, do you? I said utter bosh rubbish. He was getting all excited about his paintings because they were being recognized. He told me with great big round eyes that he'd just sold one to the government for $500. He was all up in the air about his paintings. It was nothing but that fight they had, and Shannon's fist. It may have killed him, but I think it is very unlikely. What I would like to know when they found Tom, was he dead or unconscious when he went into the water. I don't believe he was dead. I think Shannon

was in such a hurry, that he was terrified he'd killed him. And, as I say, they found this blue mark on the temple when he'd fallen. The guides would have known, but I'm pretty sure they are both dead because they were a good deal older than I was.

P. Can you tell me the first time you met Tom Thomson?

C. My husband had this thing in his chest and he had to go there and he came back from France. The doctor examined him and said that he had this T.B. gland going into his lung, very serious. I was talking to him on the telephone and I fainted. I never faint, but it was such a shock to me. I was down at the station telephoning. The only thing for him was to go up north where he could get fine air all the time, so we did.

P. Can you tell me about Tom Thomson's personality?

C. Yes, I can because I knew him quite well. I'd go out and sit with Robin [her husband, page 96, Fig. 72] and talk, all wrapped up in the cold. When he'd get drowsy, I'd go in the old dining room at Mowat Lodge, and there was Tom Thomson painting. I'd just sit quietly and wouldn't say a word until Tom talked to me, because I knew he didn't want to be disturbed. I really could write a book about it if I had somebody to do it, and somebody who knew all the names of the people around. The only ones that were there were Robin and I; we had our rooms on the far side of Mowat. Then there was the middle room, and then over on this side was Tom's room upstairs. He always joined us at night. He was a rather moody, quiet chap, and rather withdrawn. When I was with him, he'd talk away because we were pals. He evidently admired me because he gave me the painting of the year. I was a bride looking after my husband as I say. I was very interested in his painting. He would tell me about it. He would say, "now you see that bit of light down there, now where does that come from? Is that the true light? Now you have to get the true shade of light there that is coming down from the sky." He'd tell me things like that which were very interesting to me. Then at night, of course, he'd just come into the room. He was so nice about making me this jam jar. He painted these things all the way around the jar for me when Annie broke the one I'd had. He also said that he wanted me to take the painting I liked best. I told him to choose it, because he was the expert. I asked Tom why his shadows were so blue. He said tomorrow morning you go out at about 11 and go up the pathway, and just notice them. When I would go out and the sun was coming down straight, the shadows weren't really as blue as Tom made them, but when I came back a little while later, there was quite a difference in the shade of the shadows. I told you. At that time, they were terribly criticized and it was said that these paintings were alright to hang in the kitchen.

P. What painting did he give you?

C. Up here, there is a copy of it. He went and said that this painting was of the pathway that you and your husband used to go over to the other lake. I consider it the best of the year.

P. Did he have a name for it?

C. No, no name for it. I said well by all means let me have it because it was a tremendous honour although I didn't think I

Figure 72
Lieutenant Crombie
Pencil on wood (verso of sketch No. 7923)
26.7 x 21.3 cm
Photograph courtesy of the National Gallery of Canada, Ottawa

should have it. He said I want you to have it. So, I took it home. Then, there were robberies here. They stole all the curtains and little statues. I thought that I might have the painting stolen, so a woman from Vancouver that we had met asked me if she could buy the painting. I said no sir because I loved it. She said I understand, but will you make me a promise that if there is any reason that you will sell it, will you contact me? I said I would. When all these robberies were going on, I took Tom's painting and wrapped it in a blanket, put in the hall corner on a shelf, and locked the door. I was afraid of it being stolen. Then I thought, am I ever foolish to keep it because they were offering quite a lot for it. At that time $1500.00 was a lot of money. McMichael said can I have it and I said no. He came in to see it, and asked me out to lunch. I didn't sell it at that time until some years later. (Tape turned off.) Ottelyn's father had this little shack there and we used to go and see him. He looked after it very well and he was a very nice man. People used to go to see him from the hotel. This is the Hotel Algonquin.

P. Can I interrupt for a second? I'd like to hear about the time Tom Thomson painted northern lights.

C. I wasn't there then. That was before me.

P. You were telling me earlier about how he painted them.

C. That was a storm, a weird kind of storm. It happened when we were staying right in there before the spring came. He came running down the verandah helter skelter. I said to him, "What's your hurry, Tom?" He said that he wanted to get it and pointed up to the sky. I told him for heaven's sake do so. He rushed upstairs, got his paints, and came down and started. That was the day that he did it. I remember that very well. He never showed it to me afterwards which I regretted. I said that Dr. MacCallum will be coming up and I'll see it then. MacCallum did come up and he said, Come on now Tom, let's see your paintings. Tom would get out his paintings and he'd go over them all. When he came to this one, he didn't like it.

P. What year did he do this painting?

C. We were up there in 1917. In the summer of 1917, I think he was drowned. Right after that, because I remember going down to see Dr. MacCallum.

P. This is the painting here you referred to?

C. Yes.

P. It is called *Northern Lights*.

C. Well, it couldn't have been that one. Instead of that thing going up like that, it had a dark bar here and through the bars there were these streaks of light coming down, and I have never seen it since. It couldn't be *Northern Lights*.

P. Maybe it disappeared.

C. Another one that has disappeared is when Annie and I were walking along the road. Tom used to go in different places to paint, and we heard a voice. "Will you stand there for a minute." We looked up and there was Tom painting. He said that he wouldn't keep us long. She had a bright red blanket coat on and he painted these two figures in the painting. I have never seen that painting. Somebody said it was in Ottawa.

P. Mrs. Crombie, thank you very much for this interview.

Appendix II
Exhibition History during Thomson's Lifetime

1913 Toronto Ontario Society of Artists, *41st Exhibition*,
5–26 April

88 *Northern Lake*

Articles: Fergus Kyle, "The Ontario Society of Artists,"
The Year Book of Canadian Art, 1913 (London and
Toronto: J.M. Dent & Sons, Ltd. 1913), 183–89.
Mentions *Northern Lake*: 186–87.

1914 Toronto, Royal Canadian Academy of Arts,
36th Exhibition

190 *A Lake, Early Spring*
191 *Frost Lake After Rain*

Articles: Hector Charlesworth, "The R.C.A.
Exhibition," *Saturday Night*, 28 November 1914.
Mentions *A Lake, Early Spring*.

1914 Toronto, Ontario Society of Artists, *42nd Exhibition*,
14 March–11 April

137 *Morning Cloud*
138 *Moonlight*

1914 Toronto, Art Gallery of Toronto, *Exhibition of Little
Pictures by Canadian Artists (2nd Annual)*, 7–28 February

275 *Cumulus Clouds*
276 *Evening*
277 *Grey Day*
278 *Northern Lake*
279 *Winter*

1914 Toronto, Royal Canadian Academy of Arts, *Pictures and
Sculptures Given by Canadian Artists in Aid of the Patriotic
Fund*, 13 December opening

21 *In Algonquin Park*

1915 Toronto, Ontario Society of Artists, *43rd Exhibition*,
13 March–10 April

125 *Northern River*
126 *Split Rock*
127 *Georgian Bay Pines*

Articles: "Color and originality at the O.S.A.
Exhibition," *The Globe*, March 13, p. 10.
Hector Charlesworth, "O.S.A. Exhibition, 1915,"
Saturday Night, 20 March, p. 4. Mentions *Northern River*.

1915 Toronto, *C.N.E. Exhibition*, 28 August–13 September

240 *In Georgian Bay*
241 *Pines, Georgian Bay*

1915 Toronto, Arts and Letters Club, *Oil Sketches*, December

1916 Toronto, Ontario Society of Artists, *44th Exhibition*,
11 March–15 April

123 *The Birches*
124 *Spring Ice*
125 *Moonlight*
126 *The Hardwoods*

Articles: "Extremes Meet at O.S.A. Show," *The Globe*, 11
March, p. 8.

1916 Toronto, *C.N.E. Exhibition*, 26 August–11 September

Moonlight

1916 Montreal, Royal Canadian Society of Artists, *38th
Exhibition*, 16 November–16 December

The Hardwoods

Endnotes

Preface and Acknowledgements
Tom Thomson: Sources of His Brilliance

1 Harold Town and David P. Silcox, *Tom Thomson: The Silence and the Storm*, 2nd ed. (Toronto: McClelland & Stewart, 1982), 30.
2 *Mark Robinson Talks about Tom Thomson*, transcript of a tape recording made at Canoe Lake (interview by Alex Edmison), in William T. Little, *The Tom Thomson Mystery* (Toronto: McGraw-Hill, 1970), 204.

Chapter One
Spring in Algonquin Park:
Tom Thomson's Diary

1 Mark Robinson to Blodwen Davies, 23 March 1930. Blodwen Davies Papers (MG30 D24, Vol. I), National Archives of Canada (hereafter BDP, NA). See also an interview with Mark Robinson by Alex Edmison, Algonquin Park, 1952, Joan Murray, Tom Thomson Papers, The Robert McLaughlin Gallery (hereafter JM, TTP), for a slightly different version. (The letter and a section of the interview are reproduced in Appendix I, "From the Archives.") Park wardens were originally called park rangers. I have used the present-day title to avoid confusion.
2 Notes at a meeting of the Brodie Club held at the Royal Ontario Museum of Zoology, 22 December 1925, attached to a letter of 9 March 1928, from J.R. Dymond to R.B. Thomson, Royal Ontario Museum Library Archives (hereafter ROMLA), SC20A.
3 Ibid.
4 Ibid.
5 See Charles Trick Currelly, *I Brought the Ages Home* (Toronto: The Ryerson Press, 1956), 9.
6 Notes at a meeting of the Brodie Club (ROMLA).
7 Carl Berger, *Science, God, and Nature in Victorian Canada* (Toronto: University of Toronto Press, 1982), 33.
8 Ibid.
9 Ernest Thompson Seton, *Trail of an Artist-Naturalist* (New York: Charles Scribner's Sons, 1940), 165. Notes at a meeting of the Brodie Club (ROMLA).
10 Ibid.
11 Letter from Maud Varley to Joan Murray, 15 March 1971, JM, TTP.
12 Ibid.
13 "A Naturalist's Work," *The Globe*, 31 August 1903, ROMLA SC20A.
14 Frank Morris to Dr. Brodie, postmarked 8 April 1907, discusses the trip, ROMLA.
15 Harry B. Jackson to Blodwen Davies, 5 May 1931, BDP, NA.
16 A.Y. Jackson to Dr. J.M. MacCallum, 13 October 1914, Curatorial Archives, National Gallery of Canada (hereafter NGC).
17 Robinson to Davies, 11 May 1930, BDP, NA.
18 Tom Thomson to S.J. Harkness, April 1917 (postmarked 23 April), Mrs. J. Fisk, Owen Sound.
19 Mark Robinson to Blodwen Davies, 23 March 1930, BDP, NA.
20 Unfortunately, some of these pencil notations have become illegible since I recorded them over twenty years ago.
21 Tom Thomson to Dr. J.M. MacCallum, 7 July 1917, Tom Thomson Collection (MG 30 D284, Vol. 1), National Archives of Canada (hereafter TTC, NA).
22 Tom Thomson to Dr. J.M. MacCallum, 21 April 1917, TTC, NA.
23 Ann Bermingham, *Landscape and Ideology* (Berkeley: University of California Press, 1986), 11.
24 Ibid.
25 Jonathan Bordo, "Tom Thomson *The Jack Pine:* Becoming Tree or the Erasure of the Aboriginal Presence from the Visual Image of the Land," paper delivered at the Association for Canadian Studies Meeting, University of New England, Armidale, Australia, 20 July 1990.
26 Ibid.
27 Lawren Harris, "The Story of the Group of Seven," in Joan Murray, *The Best of the Group of Seven* (Toronto: McClelland & Stewart, repr. 1993), 28.

Chapter Two
The Landscape of His Childhood and Youth; His Adventures in Seattle

1 *A Souvenir of Owen Sound, Canada* (Toronto: Grip Printing and Publishing, 1908).
2 "The Tom Thomson 100th Anniversary Re-issue," Tom Thomson Memorial Art Gallery and Museum of Fine Art, Owen Sound, Ont., 1977.
3 Letter from Alan H. Ross to Blodwen Davies, 11 June 1930, 5, BDP, NA (MG 30, D 38, Vol. 11).
4 William Graham interview with Wilson Buzza, 7 August 1973, JM, TTP.
5 Ibid.
6 Ottelyn Addison, *Early Days in Algonquin Park* (Toronto: McGraw-Hill Ryerson, 1974), 124.

7 A.Y. Jackson, *A Painter's Country* (Toronto: Clarke, Irwin, 1964), 27; Leonard Rossell, "The Grip," unpublished MS., 4, NGC.

8 The discussion group was mentioned in a personal interview with Laura Davies, Toronto, 5 June 1972, JM, TTP.

9 Rudyard Kipling, *The Light That Failed* (London: Macmillan and Co., 1913), 144.

10 Maud Varley to Joan Murray, 15 March 1971, JM, TTP.

11 Interview with Mrs. Solomon Hannant, Toronto, 17 November 1970, JM, TTP.

12 *Sand Hill on the Road to South River* (1915), private collection, Owen Sound.

13 A.Y. Jackson interview with Chuck Matthews, 1965, Audio-Visual Department, Art Gallery of Ontario (hereafter AGO).

14 Lawren Harris, "The Story of the Group of Seven," in Joan Murray, *The Best of the Group of Seven* (Toronto: McClelland & Stewart, repr. 1993), 28.

15 Ibid.

16 Ibid.

17 Ibid.

18 Letter from Maud Varley to Joan Murray, 15 March 1971, JM, TTP.

19 Lawren Harris, "The Story of the Group of Seven."

20 Letter from Alan H. Ross to Blodwen Davies, 11 June 1930, BDP, NA.

21 A.H. Robson, *Tom Thomson* (Toronto: The Ryerson Press, 1937), 5.

22 *History of Sydenham Township*, 1967 (Owen Sound, Centennial Project, 1967), 531–32.

23 Margaret Tweedale, personal interview, 12 February 1971, JM, TTP.

24 Minnie Henry to Blodwen Davies, 11 June 1930, BDP, NA.

25 Alan H. Ross to Blodwen Davies, 11 June 1930, BDP, NA.

26 Victor Lauriston, "McLachlan's C.B.C. Was Notable School," *Chatham Daily News*, 7 November 1957.

27 For the listing of Thompson (*sic*), see *Vernon's City of Chatham Directory 1900–1902*, 110. I recorded the two watercolours which are owned privately in St. Thomas, Ont., in the *catalogue raisonné*, JM, TTP.

28 *Canada's Greatest Business College* (Chatham: Canada Business College, 1904).

29 Advertisement for Canada Business College, the Kent County Newspapers, Toronto Archives. For the principal's specialty, see Lauriston, "McLachlan's C.B.C. Was Notable School."

30 George Thomson, interview, 4 November 1970, JM, TTP.

31 Henry Thomson to Blodwen Davies, written by Ralph Thomson, 19 November 1946, BDP, NA.

32 Edith Maring Wiley to Joan Murray, 16 July 1971, JM, TTP.

33 Fraser Thomson to Blodwen Davies, 19 May 1930, BDP, NA.

34 Henry Thomson to Blodwen Davies, written by Ralph Thomson, 19 November 1946, BDP, NA.

35 *Twelfth Census of the United States*, taken in the year 1900, United States census office 1901.

36 Alice Lambert to Joan Murray, Darrington, Washington, 5 November 1971, JM, TTP.

37 Ruth Thomson Wilkins to Elva Henry, 23 May 1971, JM, TTP.

38 Ernest Freure to Blodwen Davies, 19 November 1935, BDP, NA.

Chapter Three
The Toronto Years

1 *Annual Report* (Toronto: Board of Trade, 1903), 119.

2 A.Y. Jackson, *A Painter's Country* (Toronto: Clarke, Irwin, [paperback]), 1964, 27.

3 For confirmation of this see the letter from William Cruikshank to James Mavor, 14 February, n.d., which mentions Thomson, Art Gallery of Ontario Archives (hereafter AGOA).

4 For more information about the impact of the railway on commercial art in Canada, see E.J. Hart, *The Selling of Canada* (Banff: Altitude Publishing, 1983).

5 L. Rossell, "The Grip," 3, unpublished MS., National Gallery of Canada Library, Ottawa.

6 Tom Thomson to Dr. M.J. McRuer, postmarked 17 October 1912, McMichael Canadian Art Collection Archives (hereafter MCACA).

7 A.H. Robson, *Tom Thomson* (Toronto: Ryerson Press, 1937), 6.

8 A.Y. Jackson, "Foreword," in Davies, *Tom Thomson*, 2.

9 L.H. [Lawren Harris], "Hemming's Black and White," *The Lamps* 1, no. 1 (October 1911): 11.

10 A.H. Robson, *Canadian Landscape Painters* (Toronto: Ryerson Press., 1932), 140; F.B. Housser, *A Canadian Art Movement* (Toronto: Macmillan, 1926), 60–61.

11 Tom Thomson to McRuer.

12 For more information about Thomson's photography, see Dennis Reid, *Photographs by Tom Thomson*, bulletin no. 16 (Ottawa: National Gallery of Canada, 1970).

13 See, for example, H.B. Froehlich and B.E. Snow, *Text Books of Art Education Book VII* (New York: Prang, 1905). The copy I saw of this book was used by a student at Hamilton Normal School.

14 A.Y. Jackson interview with Chuck Matthews, 3 October 1965, AGO (transcript), 7.

15 Thomas W. Gibson, "Algonquin National Park," *Canadian Magazine of Politics, Science, Art and Literature*, October 1894, 543.

16 The name Thomas Thomson appears in the 1913 pay list published in the Ontario Legislative Assembly *Sessional Papers* 46, part 2 (1914): 26.

17 Lawren Harris, "The Story of the Group of Seven," in Joan Murray, *The Best of the Group of Seven* (Toronto: McClelland & Stewart, repr. 1993), 28.

18 Ottelyn Addison, *Early Days in Algonquin Park* (Toronto: McGraw-Hill Ryerson, 1974), 125.

19 A.Y. Jackson to J.E.H. MacDonald, 4 August 1917, MCACA.

20 Arthur Lismer, "Algonquin Park," May 1914, unpublished MS., JM, TTP.

21 Varley mentioned his help to Thomson to Kathleen McKay. Kathleen McKay, interview, 25 February 1971, JM, TTP.

22 A.Y. Jackson, interview, 4 March 1971, JM, TTP.

23 Ibid.

24 His sister said he learned about art through borrowing books from the library. Margaret Tweedale, interview, 12 February 1971, JM, TTP.

25 Harris, "The Story of the Group of Seven," 29.

26 F.B. Housser, *A Canadian Art Movement: The Story of the Group of Seven* (Toronto: Macmillan Co. of Canada Ltd., 1926), 91.

27 Ross to Davies, 11 June 1930.

28 Robinson to Davies, 23 March 1930.

29 Ibid.

30 Dr. J.M. MacCallum to Bobby [R.A. Laidlaw], 24 January 1930, TTC, NA (MG 30 D 284, Vol. I).

31 Ibid.

32 T.W. Dwight to Martin Baldwin, 25 August 1953 and 14 January 1955, AGOA.

33 Ibid.

34 Hon. J.C. McRuer, interview, 13 November 1970, JM, TTP.

35 Rudyard Kipling, *The Light That Failed* (London: Macmillan, 1913), 47.

36 Tom Thomson to Dr. J.M. MacCallum, 4 October 1916 (?), NGC.

37 Mark Robinson often repeated this phrase of Thomson's. He was quoted by S.E. Reid in "Through a Woodman's Eyes," MS. in BDP, NA.

38 Robinson to Davies, 23 March 1930. I have left the punctuation much as it was in the letter.

39 Lismer, "Algonquin Park," JM, TTP.

40 Ottelyn Addison to Joan Murray, 9 July 1991, JM, TTP.

41 Bermingham, *Landscape and Ideology*, 126.

42 Hector Charlesworth, "The R.C.A. Exhibition," *Saturday Night*, 28 November 1914.

43 Elizabeth Harkness to Dr. J.M. MacCallum, 19 February 1918, MacCallum Correspondence, NGC. The shoes were mentioned in later family correspondence, TTC, NA.

44 Blodwen Davies, *Tom Thomson*, 50; J.M. MacCallum, "Tom Thomson: Painter of the North," *The Canadian Magazine* 50 (March 1918): 382.

45 Tom Thomson to John Thomson, 23 January 1917, TTC, NA.

Chapter Four
Echoes of Tom Thomson

1 William T. Little, *The Tom Thomson Mystery* (Toronto: McGraw-Hill, 1970), 77.

2 Ibid.

3 Roy MacGregor, in "The Legend," interviewed Daphne Crombie, *The Canadian (Toronto Star)*, 15 October 1977, 2–7.

4 Interview with Daphne Crombie by Ronald Pittaway, 14 January 1977, Algonquin Park Museum Archives, Whitney. (See Appendix I, "From the Archives," #13.)

5 Ibid.

6 Telegrams from J. Shannon Fraser to Dr. MacCallum, 10 (?) and 16 July 1917; letter 12 July 1917, NGC.

7 Letter from J. Shannon Fraser to John Thomson, 18 July 1917, BDP, NA.

8 Charles F. Plewman, "Reflections on the Passing of Tom Thomson," *Canadian Camping* 24 (Winter issue, 1972): 8.

9 Letter from Margaret Thomson to Dr. MacCallum, 9 September 1917, NGC.

10 Letter from J.S. Harkness to Dr. MacCallum, 19 February 1918.

11 Catherine D. Siddall, *The Prevailing Influence: Hart House and the Group of Seven, 1919–1953* (exhibition catalogue) (Oakville: Oakville Galleries, 1987), 53.

12 Crombie interview with Pittaway.

13 A.Y. Jackson, *A Painter's Country: The Autobiography of A.Y. Jackson*, paperback (Toronto: Clarke, Irwin, 1964), 40.

14 Franklin Carmichael to Arthur Lismer, n.d. (July 1917?), 2, MCACA.

15 Ibid.

16 Ibid.

17 J.E.H. MacDonald, "A Landmark of Canadian Art," *The Rebel 2* (November 1917): 45–50.

18 George Thomson to Dr. J.M. MacCallum, 21 July 1917, TTC, NA.

19 J.E.H. MacDonald sketchbook, 1914–22, page dated 22 October 1917, NGC.

20 *Ontario Society of Artists, Toronto, President's Annual Report for the Year Ending Feb. 28th*, 1918, 6.

21 MacCallum, "Tom Thomson: Painter of the North," *Canadian Magazine* 50 (March 1918): 375–85.

22 Ibid.

23 Ibid.

24 A.Y. Jackson, "Foreword," in *Catalogue Of An Exhibition Of Paintings By The Late Tom Thomson* (Montreal: Montreal Arts Club, 1919).

25 *Catalogue of Memorial Exhibition of Paintings by Tom Thomson, and of a collection of Japanese colour prints, loaned by Sir Edmund Walker, February 13 to 29, 1920*, Art Gallery of Toronto, 1920.

26 *The Glasgow Herald*, 28 May 1924.

27 Estate list, TTC, NA.

28 George Thomson to Dr. J.M. MacCallum, 3 September 1917, TTC, NA.

29 A.Y. Jackson to Mrs. Harkness, 12 January (1922?), TTC, NA.

30 Ibid.

31 Ibid.

32 Letter to Mrs. Harkness, 18 January 1926, TTC, NA.

33 Robert Ross, interview, 8 April 1971, JM, TTP.

34 F.B. Housser, *A Canadian Art Movement* (Toronto: MacMillan, 1926), 120.

35 MacCallum to Bobby [R.A. Laidlaw], 24 January 1930.

36 Ibid.

37 Gordon Rayner to Murray, 11 February 1991, JM, Artists' Files, RMG.

Bibliography

1 Blodwen Davies, *A Study of Tom Thomson* (Toronto: Discus Press, 1935); Blodwen Davies, *Tom Thomson: The Story of a Man Who Looked for Beauty and for Truth in the Wilderness* (Vancouver: Mitchell Press, 1967).

2 Ottelyn Addison and Elizabeth Harwood, *Tom Thomson: The Algonquin Years* (Toronto: Ryerson Press, 1969).

3 Joan Murray, *The Art of Tom Thomson* (exhibition catalogue) (Toronto: Art Gallery of Ontario, 1971).

4 Harold Town and David P. Silcox, *Tom Thomson: The Silence and the Storm*, 2nd ed. (Toronto: McClelland & Stewart, 1982), 30.

Bibliography

The literature has helped make Thomson a heroic Natural Man. In 1935 Blodwen Davies subtitled *A Study of Tom Thomson*, "The Story of a Man who looked for Beauty and for Truth In The Wilderness."[1] She discusses the legend of Thomson as a woodsman but decides to see him simply as a "positive man." Like many who explore the material on Thomson, she became engrossed in her subject, often calling him a genius. A.Y. Jackson contributed a foreword to a revised edition of the same book in 1967: though Jackson demonstrated his usual myopia about Toronto art life (he was from Montreal) and claimed there were no good paintings to be seen in the city (forgetting that the Art Museum of Toronto came into existence in 1910), his account is distinguished by one great omission – his own role in developing Thomson's work. Later books reinforce the image of Thomson in the wilderness.[2]

My own contribution to the literature, the catalogue for *The Art of Tom Thomson*, was marked by perhaps too great an enthusiasm in the other direction. I saw Thomson as doing semi-abstract painting as early as 1914. "Every autumn from that time on led him to the same results," I wrote, "a series of colour notes which are pure lyrical abstractions … The culmination of these experiments was in the year 1916, the autumn before the artist died." If Thomson had lived, "truly abstract or non-figurative art would have appeared in Canada much sooner than it did," I concluded, and I compared Thomson's ambiguous position in Canadian art to that of the Russian, Wassily Kandinsky.[3] Kandinsky had lived through the rich, colourful semi-abstractions of his Murnau period to become a pioneer abstract artist. Today, we see Thomson's abstractions as a random experiment, not a concerted program, though had he lived, he might well have continued them. Nevertheless, the idea that Thomson was a pioneer in abstraction remains valid and has proved influential. Harold Town in particular took up the argument.[4]

Overall, however, Thomson literature is remarkable for its paucity. American enthusiasts would likely have made more of him had he been theirs. Still, interest in his work in the United States continues to grow; in fact, one of his paintings was used on the invitation to a show, *Post-Impressionism and North American Art, 1900–1910*, at the High Museum of Art in Atlanta, Georgia (1986).

Selected Bibliography

Primary Sources

Blodwen Davies Papers (MG 30 D24), National Archives of Canada, Ottawa.

Lawren Harris Papers (MG 30 D208), National Archives of Canada, Ottawa.

Dr. James M. MacCallum Papers, National Gallery of Canada, Ottawa.

Joan Murray, *Tom Thomson, Catalogue Raisonné.* Various interviews, letters, photographs, and lists; and the William Graham Papers, The Robert McLaughlin Gallery, Oshawa, Ontario.

Tom Thomson Collection (MG 30 D284), National Archives of Canada, Ottawa.

Various letters, The McMichael Canadian Art Collection, Kleinburg.

Interview with Daphne Crombie, Algonquin Park Museum, Whitney, Ontario.

Useful Articles and Books

Addison, Ottelyn. *Early Days in Algonquin Park.* Toronto: McGraw–Hill, Ryerson, 1974.

———— and Harwood, Elizabeth. *Tom Thomson, Algonquin Years.* Vancouver, Winnipeg, and Toronto: Ryerson Press, 1969.

Berger, Carl. *Science, God, and Nature in Victorian Canada.* Toronto: University of Toronto Press, 1982.

Bermingham, Ann. *Landscape and Ideology.* Berkeley: University of California Press, 1986

Bordo, Jonathan. "Jack Pine — Wilderness sublime or erasure of the aboriginal presence from the landscape." *Journal of Canadian Studies* 27, no. 4 (Winter 1992–93), 98–127.

Brown, F. Maud. *Breaking Barriers.* Toronto: Society for Art Publications, 1964.

Colgate, William. *Two letters of Tom Thomson, 1915 & 1916.* Weston, Ont.: Old Rectory Press, 1946.

Daniels, Stephen. *Fields of Vision.* Oxford: Polity Press, 1993.

Davies, Blodwen. *A Study of Tom Thomson: The Story of a Man Who Looked for Beauty and for Truth in the Wilderness.* Toronto: Discus Press, 1935.

————. *Tom Thomson. The Story of a Man Who Looked for Beauty and for Truth in the Wilderness.* Reprinted. Vancouver: Mitchell Press, 1967.

Frayne, Trent. "The Rebel Painter of the Pine Woods." *Maclean's Magazine*, July 1953, 16–17, 30–33.

The Fundamentals of the Printing and Duplicating Processes. N.p.: Howard Smith Paper Mills, 1949.

Gauslin, Lillian M. *From Paths to Planes: A Story of the Claremont Area.* Claremont, Ont.: By the Author, 1974.

Glazebrook, George P. de T. *The Story of Toronto.* Toronto: University of Toronto Press, 1971.

Housser, F.B. *A Canadian Art Movement.* Toronto: Macmillan, 1926.

Hubbard, R.H. *Tom Thomson.* The Gallery of Canadian Art, no. 2. Toronto: Society for Art Publications/McClelland & Stewart, 1962.

Jackson, A.Y. *A Painter's Country.* Toronto: Clarke, Irwin, 1958.

Lismer, Arthur. "Tom Thomson 1877–1917, a Tribute to a Canadian Painter." *Canadian Art* 5 (Christmas 1947), 59–62.

————. "Tom Thomson (1877–1917) Canadian Painter." *Educational Record of the Province of Quebec* 80 (July–September 1954), 170–75.

Little, William T. *The Tom Thomson Mystery.* Toronto: McGraw–Hill, 1970.

MacCallum, J.M. "Tom Thomson: Painter of the North." *Canadian Magazine* 50 (March 1918), 375–85.

MacGregor, Roy. "The Legend. New Revelations on Tom Thomson's Art — and on his Mysterious Death." *Toronto Star, The Canadian*, 15 October 1977.

————. *Shorelines, a Novel.* Toronto: McClelland & Stewart, 1980.

McLeish, John A.B. *September Gale.* Toronto and Vancouver: J.M. Dent & Sons, 1955.

Mitchum, Allison. *The Northern Imagination: A Study of Northern Canadian Literature.* Moonbeam, Ont.: Penumbra Press, 1983.

Murray, Joan. *The Art of Tom Thomson* (exhibition catalogue). Toronto: Art Gallery of Ontario, 1971.

————. "The Artist's View: The Tom Thomson Mystique." *Artmagazine*, no. 37 (1978): 2–5.

————. *The Best of the Group of Seven.* Edmonton: Hurtig Publishers, 1984; repr. Toronto: McClelland & Stewart, 1993.

————. *The Best of Tom Thomson.* Edmonton: Hurtig Publishers, 1986.

————. *Northern Lights: Masterpieces of Tom Thomson and the Group of Seven.* Toronto: Key Porter, 1994.

————. "The World of Tom Thomson." *Journal of Canadian Studies*, 26 (Fall 1991), 5–51.

Newell, Gordon and Sherwood, Don. *Totem Tales of Old Seattle: Legends and Anecdotes.* New York: Ballantine Books, 1956.

Northway, Mary L. *Nominigan, a Casual History.* Toronto: Brora Centre, 1969.

Quinney, Bill, "Tom Thomson: A Naturalist Painter," unpublished paper for the Master's Degree, University of Toronto (JM, TTP).

Reid, Dennis. *The MacCallum Bequest* (exhibition catalogue). Ottawa: National Gallery of Canada, 1969.

————. *Photographs by Tom Thomson*. Bulletin no. 16. Ottawa: National Gallery of Canada, 1970.

————. *Tom Thomson, The Jack Pine*. Masterpieces in the National Gallery of Canada, no. 5. Ottawa: National Gallery of Canada, 1975.

Robson, A.H. *Canadian Landscape Painters*. Toronto: Ryerson Press, 1932.

————. *Tom Thomson*. Toronto: Ryerson Press, 1937.

Seton, Ernest Thompson. *Trail of an Artist-Naturalist*. New York: Charles Scribner's Sons, 1940.

Stacey, Robert. "Tom Thomson: Deeper into the Forest," *OKanada* (catalogue). Berlin: Akademie der Künste, 1982–83.

Sowby, Joyce K. "Quality Printing. A History of Rous and Mann Limited, 1909–1954." N.p., 1969.

Toronto. Art Gallery of Ontario. *100 Years: Evolution of the Ontario College of Art* (exhibition catalogue). Toronto: Art Gallery of Ontario, 1977.

Town, Harold, and David P. Silcox. *Tom Thomson: The Silence and the Storm*. 2nd ed. Toronto: McClelland & Stewart, 1982.

Ufland, Vina R. *History of Sydenham Township*. Owen Sound, Ont.: n.p., 1967.

Welsh, Jonathan. *Letter to The West Wind*. Moonbeam, Ont.: Penumbra Press, 1980.

Wistow, David. *Tom Thomson and the Group of Seven*. Toronto: Art Gallery of Ontario, 1982.

Yearbook of Canadian Art 1913. London and Toronto: J.M. Dent & Sons, 1913.

Photograph Credits

Art Gallery of Ontario, Toronto
Art Gallery of Peel, Brampton
Grey-Owen Sound Museum, Owen Sound
D. W. Kibbey, Spokane, Washington
The London Regional Art and Historical Museums
The McMichael Canadian Art Collection and Archives, Kleinburg
National Archives of Canada, Ottawa
National Gallery of Canada, Ottawa
Ontario Archives, Toronto
Private collections, England and Canada
The Robert McLaughlin Gallery, Oshawa
Royal Ontario Museum, Toronto
Seattle Historical Society, Museum of History & History
Ken Thomson, Toronto (Alan D. Watson)
Tom Thomson Memorial Art Gallery, Owen Sound
Special Collections Division, University of Washington Libraries, Seattle, Washington

Index